The Campus History Series

UNIVERSITY OF TEXAS
AT ARLINGTON

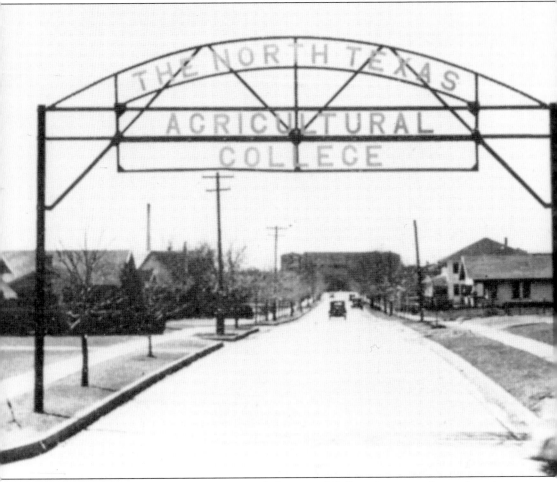

This familiar gateway at the intersection of Abram and College Streets welcomed students to the North Texas Agricultural College (NTAC). In the distance, the administration building, now Ransom Hall, faces the school's military parade ground. NTAC, part of the Texas A&M System, successfully navigated the Great Depression and the hardships of World War II while serving two decades of students. (Courtesy of the Clarence Denman Papers.)

ON THE COVER: Rebel cheerleaders pose in front of Arlington State College's new library in 1965. They are, from left to right, Lynn Petrelli, unidentified, Sharon Terrill, Buddy Lear, Becky Cowley, Mike Langdon, Sandy Barnes, and unidentified. (Courtesy of the University of Texas at Arlington Libraries Special Collections.)

The Campus History Series

UNIVERSITY OF TEXAS AT ARLINGTON

EVELYN BARKER AND LEA WORCESTER

ARCADIA
PUBLISHING

Published by Arcadia Publishing
Charleston, South Carolina

Printed in the United States of America

Library of Congress Control Number: 2014935116

For all general information, please contact Arcadia Publishing:
Telephone 843-853-2070
Fax 843-853-0044
E-mail sales@arcadiapublishing.com
For customer service and orders:
Toll-Free 1-888-313-2665

Visit us on the Internet at www.arcadiapublishing.com

For John Reed

CONTENTS

ACKNOWLEDGMENTS

The authors would like to acknowledge the stellar staff of UT Arlington Libraries Special Collections for their invaluable assistance. We thank Brenda McClurkin and Ann Hodges for their unstinting support and Cathy Spitzenburger for her irreplaceable knowledge of the photograph collections. We also thank Melissa Gonzales for her help with the university archives. Most of the photographs were obtained from the University of Texas at Arlington Library Special Collections, especially the *Fort Worth Star-Telegram* Collection, the *Arlington Citizen-Journal* Negative Collection, the Clarence Denman Papers, and the University of Texas at Arlington Photograph Collection. Unless otherwise noted, all images appear courtesy of Special Collections, the University of Texas at Arlington.

Special gratitude goes to UT Arlington Libraries dean Rebecca Bichel for her early and substantial support of this project. Without her, this project could not have begun.

No book written about the history of the university could fail to acknowledge the contributions to the subject by Junia Evans Hudspeth, who wrote *A History of North Texas Agricultural College,* and Dr. Gerald Saxon, author of *Transitions: A Centennial History of the University of Texas at Arlington, 1895–1995*. We also thank staff at UT Arlington Communications for their assistance and their efforts to document the university's history through photographs.

Our gratitude goes to Gary Spurr of the Tarleton State University Dick Smith Library for his help with the Tarleton photographs. Thank-yous go to Sara Abraham-Oxford and Dorienne Reeves for their help with photographs representing the School of Urban and Public Affairs and School of Social Work, respectively. We also wish to recognize Max Gathings for his lovingly collected and generously shared collection of photographs relating to NTAC and ASC/UTA Greek life.

Last, but never least, we thank our families. Evelyn thanks her husband, Bob, for his loving support and her sons, Will and Scott, for their patience during the writing process.

INTRODUCTION

The chronicles of the University of Texas at Arlington are too big for one slim book to cover. Students have encountered this institution in three different centuries and under eight different names:

Arlington College (1895–1902)
Carlisle Military Academy (Carlisle) (1902–1913)
Arlington Training School (1913–1916)
Arlington Military Academy (1916–1917)
Grubbs Vocational College (Grubbs or GVC) (1917–1923)
North Texas Agricultural College (NTAC) (1923–1949)
Arlington State College (ASC) (1949–1967)
University of Texas at Arlington (UTA) (1967–present)

Enrollment has gone from a few dozen children to 34,000 adults. Buildings have risen and fallen, and programs have come and gone. Given the magnitude of the project, then, how can one examine the history of UTA?

One could look through 60 years of UTA yearbooks for a sense of how the campus has changed and what was important to each era. The 1940s yearbooks feature countless photographs of men in uniform and show scenes of a college at war. The 1950s reflect the rapid changes going on in Arlington and the college. The 1960s also highlight growth, but show a more diverse campus than in previous decades.

For a microscopic look at campus life, one could read nearly 100 years of the *Shorthorn*, the award-winning campus newspaper that has been in publication since 1919. Countless students have honed their writing and photography skills at the paper and, in doing so, recorded the history of the campus. From its print origins to today's electronic publication, nothing can rival the *Shorthorn* for information about daily campus life—from each game won and lost, to the big issues of the day and the opinions of a single student.

The University of Texas at Arlington Libraries Special Collections contains hundreds of feet of material relating to the history of the university. There are handwritten letters sent to Pres. Frank Harrison with strongly worded opinions about changing the university's Rebel mascot. Oral histories with notable campus people line the shelves, preserving the memories of a bygone era. And then there are the photographs. Thousands of images record the changes on campus from its earliest days to the present.

Finally, there are all the records kept by individuals and organizations such as the band, athletic teams, Greek organizations, ROTC, clubs, alumni, and university departments that are scattered across campus and across the world. No, it would be impossible to tell the full story of this vibrant, ever-changing campus in one book, no matter its size.

Founded in 1895, Arlington College began as an alternative to the then underfunded and ill-equipped public school in town. It offered classes for students from first grade all the way to tenth, and faculty taught Latin, history, literature, algebra, and government.

Carlisle Military Academy was billed as a high-grade school for the full development of worthy boys. Girls were allowed to attend after enrollment declined and the school needed more students. The school was well regarded in North Texas and noted for its athletic programs.

The years after Carlisle closed were marked by financial insecurity, but Arlington Training School and Arlington Military Academy keep the campus running until Vincent Woodbury Grubbs convinced the Texas Legislature to appoint the site as a vocational college. Grubbs Vocational College was part of the Agricultural and Mechanical College of Texas (now Texas A&M) and offered courses in auto mechanics, agriculture, and commercial arts such as bookkeeping, typing, and stenography.

The NTAC years set the tone for the campus for decades to come. Blessed with an energetic and fearless leader, Dean E.E. Davis, the school expanded beyond vocational classes and became a true junior college. NTAC included a flight school and aircraft mechanics courses, which were deemed necessary in the turbulent years leading up to World War II.

Arlington State College took advantage of the postwar boom and began a serious quest to become a four-year degree-granting institution, a goal it achieved in 1959. But along with rapid expansion came growing pains. Campus space was tight, evidenced by the fact that the campus was forced to place the rifle range below the library. National social changes were reflected on campus with more women entering the sciences and the integration of the student body.

ASC split from the A&M System in 1965 and adopted the name University of Texas at Arlington in 1967. The campus graduated its first doctoral students in 1971 and began its rise, in the words of UTA president Wendell Nedderman, as a positive slope institution. "Every year we'll be a little better," he said.

In over a century of existence, the campus has experienced its share of highs and lows. Highs include becoming a four-year degree-granting institution in 1959 after a long hard fight with the legislature. When the campus received a 2:00 p.m. phone call saying the bill had been signed, jubilation rang out across the grounds. Classes were immediately dismissed and students celebrated in the streets.

Another high point was the 1957 undefeated football season when the Arlington State College Rebels, led by coach Chena Gilstrap, won their second straight Junior Rose Bowl in Pasadena, California.

The lows were felt during the Great Depression when Dean E.E. Davis, desperate to recruit good students, would find boys in the cornfields of East Texas and talk to them about coming to NTAC. Another low was the 1985 decision to end the football program at UTA—a move that still ignites passionate arguments.

Since becoming a postsecondary institution, the campus has endured through six wars. World War II hit the student body especially hard, with about 200 former NTAC students killed in action. Their names, and the names of those who followed them in Korea, Vietnam, and both Persian Gulf wars, are memorialized in the Hall of Honor located in College Hall. The campus's military heritage survives in the Carlisle Cannons, set off during special occasions, and the Sam Houston Rifles who have been performing precision maneuvers since 1925.

Today, UTA has shed much of its commuter school image and is no longer the best-kept secret in the Metroplex. Instead, UTA is taking leading roles in research innovation and attracting top talent from around the world. This book shows how far UTA has come and hints at what is possible in the future.

8

One

NO SCHOOL, NO TOWN

"Good schools make good towns; no schools, no town. Which will you take? Let's have the good school," argued Arlington's newspaper the *Arlington Journal*, regarding ongoing problems with education in the young town. Early Arlington lacked an essential element necessary to foster growth—adequate schools. In 1895, the small town of approximately 1,000 citizens consisted primarily of young, married couples with school-age children forced to attend ill-equipped schools. Hardware store owner Edward Rankin felt that the solution was a private academy. He recruited William Trimble and Lee Hammond, coprincipals of the Arlington Public School, to found Arlington College, which ultimately became the University of Texas at Arlington.

Arlington College was not a college in the modern definition; the school offered classes from the first grade though the tenth. It was initially a success, with approximately 75 students during its first year. Soon, the city asked the college to provide space for public school students because the public school buildings were unfit. Recognizing that this was only a temporary solution, the citizens of Arlington created the Arlington Independent School District in 1902 and approved a $12,000 bond issue for school construction. However, sharing its facilities prevented the private school from offering a full schedule of classes, and it closed in 1902. The city quickly reached an agreement with James Carlisle to start Carlisle's School for Boys, which opened September 1902. Renamed as Carlisle Military Academy and advertised as a preparatory school for manly boys, the school balanced intellectual work with military training. Carlisle proved to be an excellent educator but a terrible financial manager. The school went into receivership in 1911 and closed in 1913. In rapid succession, Arlington Training School (1913–1916) and Arlington Military Academy (1916–1917) opened with high hopes, only to find out that a private military academy was not viable. However, the legacy of the failed private schools was a campus with adequate physical facilities that formed the foundation for the development of a junior vocational college in Arlington.

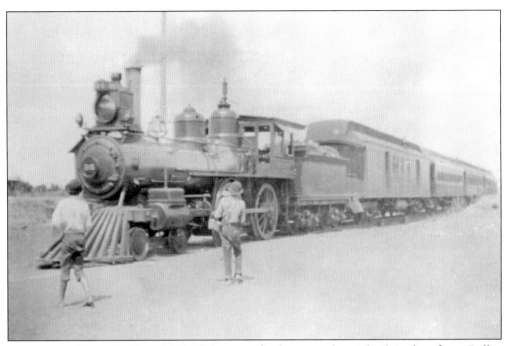

Texas & Pacific Railroad established the city of Arlington when it built its line from Dallas to Fort Worth three miles north of Johnson Station and platted a new town along the railroad tracks. Named after Robert E. Lee's home in Virginia, the small community soon boasted about its central location between Dallas and Fort Worth and easy access to rail transportation.

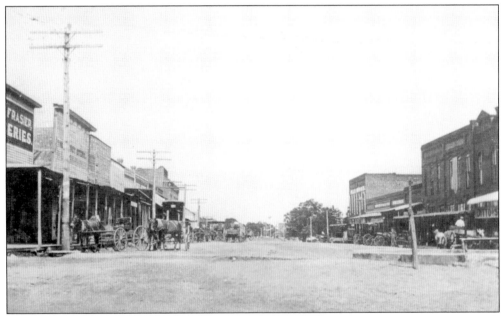

Like many railroad towns, Arlington in the late 1800s was a tough Western town with gunfights, saloons, and rowdy transients. By the turn of the century, when this photograph of Main Street was taken, the population had grown to over 1,794.

Local pioneer merchant Edward Rankin (right) was attempting to secure Arlington's future when he convinced Lee Hammond and William Trimble to found a private school in 1895. The small community's public school was underfunded and did not serve the needs of a population where the median age was 20 and one-third of the residents were under 10 years old. Arlington College was not a college as people think of them today, but rather served primary and secondary grades through 10th grade. The school's first building (below) consisted of six classrooms and a room for assembly. It is shown under construction by Frank Thomas and Joe Crawley on land provided by the Ditto and Collins Land Company. Lumber and building supplies were sold to the school at cost by local merchants. The school was built near the site of UT Arlington's current student union.

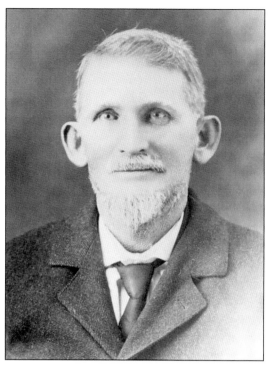

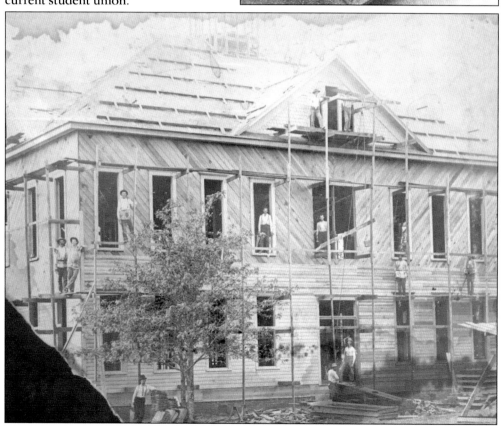

Cofounders of Arlington College, William Trimble (left) and Lee Hammond (below) met while attending Sam Houston Normal Institute in Huntsville, Texas. After graduation, they became coprincipals of Arlington Public School. In 1895, they were approached by leading businessman Edward Rankin who suggested that they build a private school based on Webb School in Bellbuckle, Tennessee. Each man invested $500 and sold $100 scholarships to parents and community leaders. Together, they taught academic subjects including Latin, history, literature, algebra, and government. In 1898, Trimble sold his interest in the school while Hammond remained until 1900 when the school experienced financial difficulties.

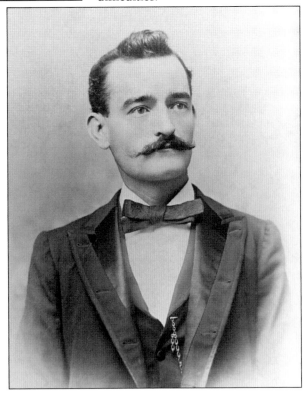

Arlington College faculty gave Fannie Watson excellent and perfect scores on her report card. While it is not certain whether she was a typical student, it is evident from the report card that the goal of the school was to graduate students skilled in reading, writing, and arithmetic, as well as the arts.

The school's income was restricted because the public school rented all but one room of Arlington College's building. College trustees sold stock during 1900 to maintain the school. A.J. Rogers, an Arlington College teacher, purchased this bond to support the school. In 1902, Arlington College closed after the citizens of Arlington voted in favor of an independent school district and the passing of a bond issue for school construction made a private school less attractive.

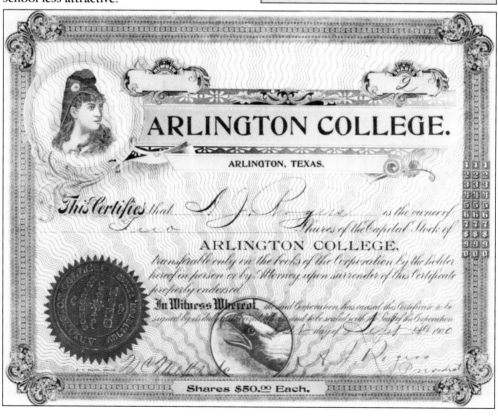

OUR STUDENTS' WORK IS OUR RECOMMENDATION.

ARLINGTON COLLEGE.
W. W. FRANKLIN, President.

REPORT OF *Miss Fannie Watson*

MONTH ENDING *May 17* DEMERITS

DEPORTMENT	92	REMARKS	
DAYS ABSENT			
TIMES TARDY			

STUDIES	Times Present.	Times Absent.	Grade.	STUDIES	Times Present.	Times Absent.	Grade.
Primary Department.				Algebra—Intermediate.			
Orthography				Algebra—Advanced			
Reading				Geometry—Plane			
Language				History—Universal.			
Writing				Literature—American			
Arithmetic				Classics—American			
Geography				Civil Government			
Nature Studies				Physics			
Drawing				Latin—Beginning			
Vocal Music				**Collegiate Department.**			
Preparatory Department.				Rhetoric—Advanced			
Spelling—Intermediate			97	Latin—Caesar			
Reading—Nature Studies				Latin—Cicero			
Grammar—Elementary				Greek—Anabasis			
Grammar—Intermediate	20		96	**Fine Arts Department.**			
Composition				Elocution			
Arithmetic—Elementary			98	Piano			100
Arithmetic—Intermediate				Violin			
Geography—Complete	20		84	Mandolin			
History—Texas				Guitar			
History—United States	20		94	Vocal			
Academic Department.				Harmony			
Word Analysis				Musical History			
Grammar—Complete				**Business Department.**			
Rhetoric—Practical				Penmanship	20		92
Arithmetic—Complete				Commercial Arithmetic			
Algebra—Elementary				Book Keeping			

100—Perfect. 90—Excellent. 85—Passing. 80—Fair. Below 75—Poor.

ARLINGTON COLLEGE.
ARLINGTON, TEXAS.

This Certifies that *S. J. Rogers* is the owner of
Two Shares of the Capital Stock of
ARLINGTON COLLEGE,
transferable only on the books of the Corporation by the holder hereof in person or by Attorney upon surrender of this Certificate properly endorsed

In Witness Whereof, the said Corporation has caused this Certificate to be signed by its duly authorized officers and to be sealed with the Seal of the Corporation

Shares $50.00 Each.

Almost immediately, Col. James M. Carlisle (left) proposed to Arlington that he would relocate his private military academy from Hillsboro, Texas. Carlisle, former Texas state superintendent of public instruction, was a notable educator and eagerly received by the citizens of Arlington. In June 1902, the city agreed to donate the property from the failed Arlington College and build a dormitory. Carlisle's School for Boys, noted for high academic and physical standards, opened that year. Carlisle and his wife, Julia, are pictured below in the garden next to the two-story frame building that served as their residence, a dining facility, and a dormitory for 30 cadets. The dormitory, called Arlington Hall, was located where Preston Hall stands today. After the first year, Texas granted a charter to the school, now named Carlisle Military Academy, as an educational institution for literary, military, and manual training for boys and a limited number of girls.

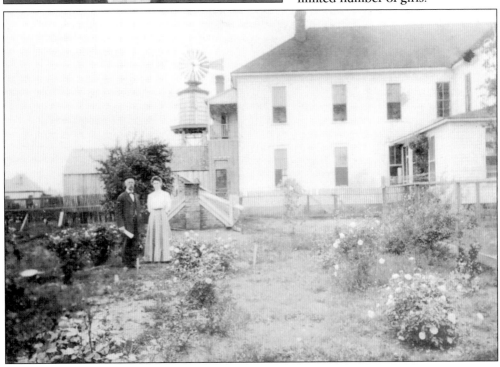

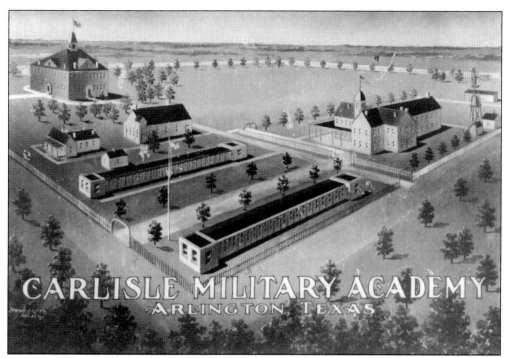

CARLISLE MILITARY ACADEMY
ARLINGTON TEXAS

This postcard featuring an aerial view of the 10-acre campus shows the long, low East and West Barracks, parade ground, and facilities. Carlisle boasted that the well-drained land ensured that cadets could drill despite rain. The corner closest to the foreground is located on what are now South West and West Third Streets near today's University of Texas Planetarium and the Chemistry and Physics Building.

Non scholae, sed vitae discimus proclaims *Carlisle Military Academy Bulletin No. 1* in 1910–1911. This was a motto fitting for a school that claimed both scholarly and military expertise. Its translation reads, "We do not learn for the school, but for life." This popular motto for schools acknowledges that it is best for students not to study hard to please a teacher, but to learn and reap the benefits later in life.

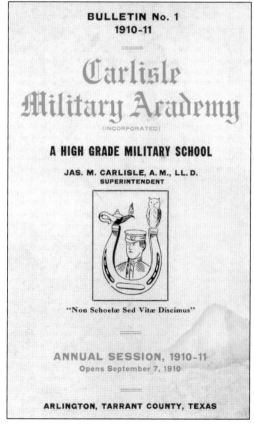

BULLETIN No. 1
1910-11

Carlisle Military Academy
(INCORPORATED)

A HIGH GRADE MILITARY SCHOOL

JAS. M. CARLISLE, A. M., LL. D.
SUPERINTENDENT

"Non Schoelæ Sed Vitæ Discimus"

ANNUAL SESSION, 1910-11
Opens September 7, 1910

ARLINGTON, TARRANT COUNTY, TEXAS

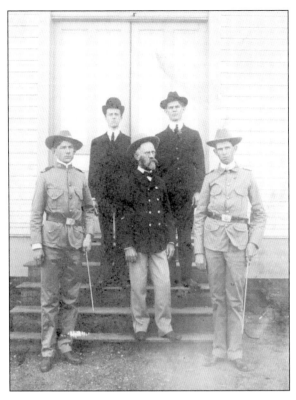

Carlisle's School for Boys faculty in the early years consisted of Carlisle, his wife, Julia, his daughter Mary, and at least four additional full-time teachers. Carlisle advocated hiring specialists because the school's students deserved the best. Carlisle Military Academy faculty pose (left) from left to right: (first row) Preston A. Weatherred, James M. Carlisle, and Garland Morton; (second row) Sydney Rowland and L.T. Cook. In 1902, Mary Carlisle (below) started her 30-year career as a Texas educator by teaching English and history at Carlisle Military. She later married Dr. Milton Cravens and resigned from teaching, but returned to the profession in 1921 after her husband's death.

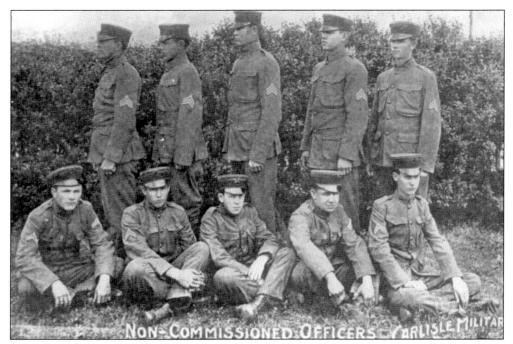

The school opened with 48 students in the fall of 1902, and it was so popular that the spring 1903 semester closed in May with 71 students. Cadets entered the academy at 10 years old and graduated at 18. Students such as these unidentified, noncommissioned officers in this undated photograph were required to follow military discipline and wear uniforms at all times. Graduates of West Point headed the military department of the academy.

Despite being advertised as a school for manly boys, the academy accepted female students when enrollment declined and needed bolstering. In 1910, all students—including, from left to right, Jessie Bardin, Ethel Roy, and Eunice Taylor—were limited to 50¢ a week spending money, which was distributed by the school.

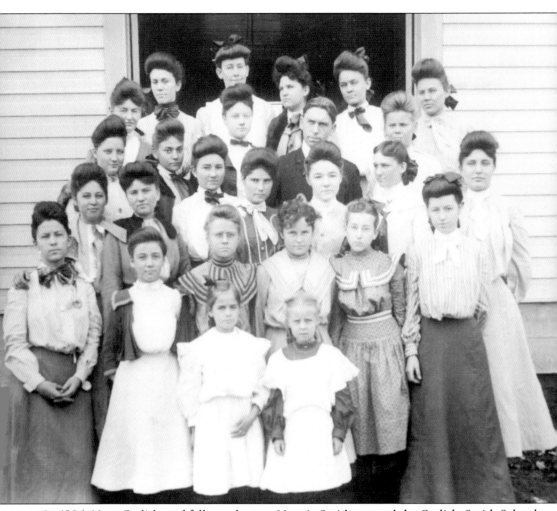

In 1904, Mary Carlisle and fellow educator Maggie Smith opened the Carlisle-Smith School for Girls on Abram Street after the military academy stopped accepting female students due to increasing enrollment placing a strain on its facilities. The 1904 class and teachers are pictured from left to right: (first row) May Weeks and Lorene Yates; (second row) Dora Coleman, Lucy Jackson, Nita Martin, Ethel Gill, Pearl Wade, and Bertha Marney; (third row) Cora Trigg, Pearl Hutchison, Mattie Norman, Virgil Pilant, Grace Moore, Mattie Mathers, Sue McKnight; (fourth row) Ammon McKinley, Laura Jackson, Stella McKinley,? Delaney, Helen Copeland; (fifth row) Mary Cravens, Mary Carlisle, Maggie Smith, Allie Mathers, Matt Copeland, and Frances Watson. Wade, among others, looked forward to Saturday afternoon dances and military balls with young Carlisle cadets. The school closed after one year and female students could not go to a private school in Arlington until Carlisle Military Academy began enrolling girls again in the fall of 1908 after enrollment dropped due to a downturn in the economy in 1907 and a regional drought.

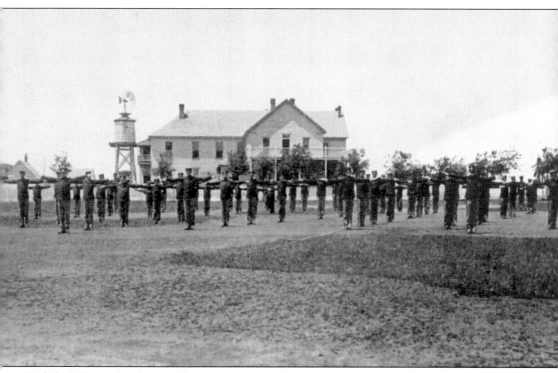

Carlisle Military Academy cadets were expected to participate in a wide range of physical activities including exercising, baseball, basketball, football, and track. Military exercises included sham battles, drills, and parades. The focus on physical fitness was an important part of Carlisle's belief that military life, with regulation and drill as well as scheduled sleep and meals, would instill in the youth the discipline, sense of duty, and honor that would prepare them for entrance into the finest colleges in the country. Carlisle was regarded as one of the leading educators in the state, and his views on both academic and physical education were received with enthusiasm by parents.

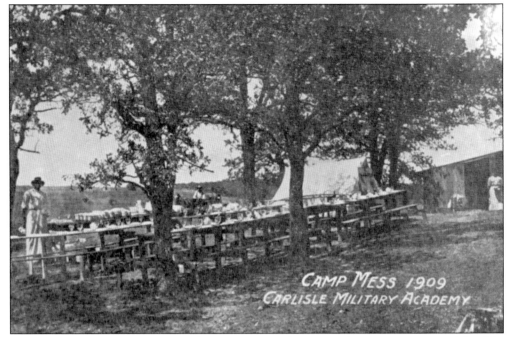

The campus mess in 1909 resembled a picnic where outside activities assured healthy bodies. Carlisle believed in wholesome food and discouraged parents from sending cadets packages containing cookies, cakes, and candies. The school also forbade both students and staff to use tobacco. Carlisle felt that decisions about the students should be left to the faculty because they knew what was best.

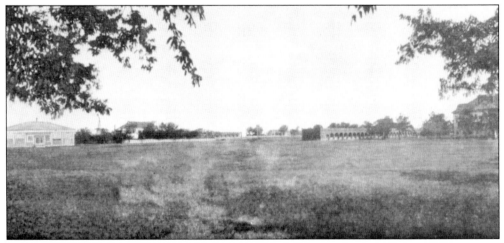

The academy soon occupied a four-block area in what is now the northeast part of the UT Arlington campus where University Center, Preston Hall, and Ransom Hall now stand. This 1910 view shows the newly built swimming pool, barracks, and administration building. Unfortunately, Carlisle's financial problems, caused by declining enrollment and building costs for facilities such as the swimming pool, forced the school into receivership a year later. The school operated for two more years before it closed.

Henry Kirby Taylor, president of Northwest State Teachers' College in Marysville, Missouri, quickly reached an agreement with the owners of the Carlisle Military Academy property and established the Arlington Training School. The advisory board and facilities remained almost the same in the newly created school. The 1914 school year's enrollment was 69 students. Tuition and expenses for a school year ranged from $225 to $300.

The unidentified students in this Arlington Training School sophomore photograph are wearing the prescribed school uniform. When it opened in 1913, Arlington Training School continued the tradition of military training with an additional focus of individualized mentoring of students by faculty. The school sought upper-class students and required all boarding students to attend the church or Sunday school of their choice.

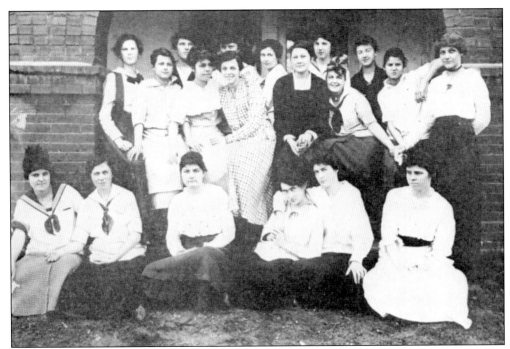

Girls admitted to the college were offered academic courses with an additional focus on music. The school's plans for offering domestic science were placed on hold due to a lack of facilities. The school encouraged the unidentified girls in this Martha Washington Literary Society photograph to become proficient in public speaking, debate, and composition.

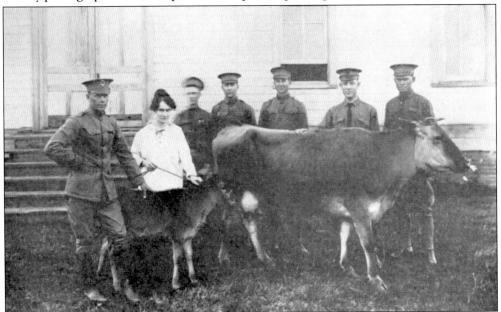

Arlington Training School's program of study included English, mathematics, history, sciences, languages, and vocational subjects. The seven unidentified students with a calf and cow are part of the agriculture class. After graduating from the school, students met the qualifications for entering the University of Texas and other institutions of higher learning.

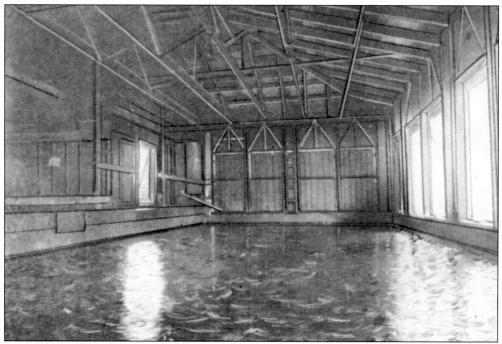

The 1914–1915 catalog reassured parents that the school also believed in wholesome athletics. The publication features this picture of the swimming pool as an example of opportunities for indoor exercise. In addition, every student was required to do sitting-up exercises each morning as part of his physical training.

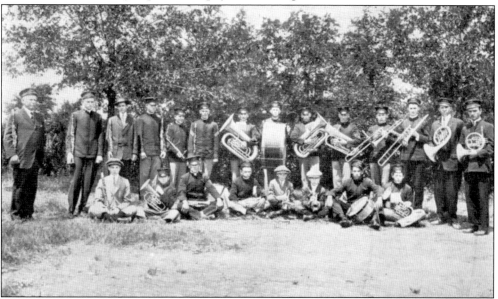

A special course for young students who wished to teach music after graduation included two lessons each week for $5 a month. The school band offered students opportunities to practice and play during military drills. Renovations in the summer of 1915 seemed to celebrate the school's continuing success. However, financial trouble and lawsuits during the spring of 1916 led Taylor to leave Arlington. The town once again lacked a private school.

In 1916, John B. Dodson stated that he would continue along the lines of Carlisle and Taylor and build upon their achievements when he opened the Arlington Military Academy on the newly available campus. The new academy continued to offer athletics and rigorous military discipline in order to foster development as well as courses in literature and oratory to prepare students for either college or business. Enrollment did not meet expectations during the fall semester and failed to increase enough in the spring semester to assure that the school would continue. Arlington Military Academy only lasted a year. The citizens of Arlington ended their support of private education and began to explore the possibility of securing a junior college.

Two

A COLLEGE FOR THE COMMUNITY

At last, in 1917 Arlington had a proper college. After the failure of several private military schools, the community had achieved a major goal, Grubbs Vocational College. The college was a branch of the Agricultural and Mechanical College of Texas, now Texas A&M University. Named after Judge Vincent Woodbury Grubbs, the school served rural and small-town Texas by offering students agricultural and mechanical education that would prepare them for work on farms and in growing industries. Grubbs devoted several decades to working and lobbying for vocational education colleges and was instrumental in the legislation that founded the college.

Myron L. Williams, appointed as dean, supervised the change from a private military school to a junior college. The curriculum included two years of secondary and two years of collegiate studies, and students had to be at least 14 years old upon matriculation. The campus consisted of the former Arlington Military Academy and 100 acres purchased from James Fielder for a demonstration farm. The Texas Legislature appropriated $112,500 for a new administration building, now called Ransom Hall. In all schools that were founded by the Morrill Act of 1866, students were required to participate in military training. Registration for the first semester was only 66 students. The low number was probably due to young men being drafted for service in World War I. Grubbs Vocational College actively supported the war with the establishment of the Student Army Training Corps to educate and train students before they entered officer training. By 1919, there were 444 students studying agriculture and mechanics as well as stenography, commercial law, bookkeeping, banking, and household arts. In addition to a rich and varied campus life, the students published the student newspaper, the *Shorthorn*, which is still in publication.

After six years, Grubbs Vocational College had grown from 66 to 808 students, developed a vital curriculum designed to support the vocational needs of an industrial nation, and featured a well-maintained campus. By 1923, the word *vocational* was seen as hindering the school's development, while the name Grubbs Vocational College seemed to indicate a privately funded school. Dean Williams appealed to the Agricultural and Mechanical College of Texas for a new name.

Judge Vincent Woodbury Grubbs supported the industrial education movement, which proposed that it was important to train the nation's youth in useful skills that would enable them to contribute to the development of a country that needed farmers and mechanics. Arlington leaders accepted Grubbs's offer to lobby for a vocational school during the 35th legislature session. In March 1917, Gov. James Ferguson signed a bill to establish Grubbs Vocational College.

William B. Bizzell, then president of the Agricultural and Mechanical College of Texas (now Texas A&M University), regarded Grubbs Vocational Collage as a branch and gave Myron L. Williams (right) the title of dean when he assumed charge of the newly founded college in 1917. Williams immediately inspected the property, found it in disrepair, and began a budget and plans for its renovation. Williams was to successfully lead Grubbs Vocational College and later North Texas Agricultural Collage.

Among the first improvements was the acquisition of 100 acres of land to be added to the approximately 10 acres deeded to the Arlington Military Academy by Frank McKnight, acting president of the Arlington Training School. Citizens of Arlington's nearby counties donated $10,000 to purchase the land where Maverick Stadium and J.D. Wetsel Service Center are today from James P. Fielder. Fielder (right) generously donated $1,000.

The legislature appropriated $112,500 for a new administration building, which was finished in spring of 1919. The new structure included administrative offices, a library, labs, classrooms, and an auditorium with motion picture and lanternslide machines. The fireproof building with modern features such as electricity and plumbing remains on campus today and is now called Ransom Hall.

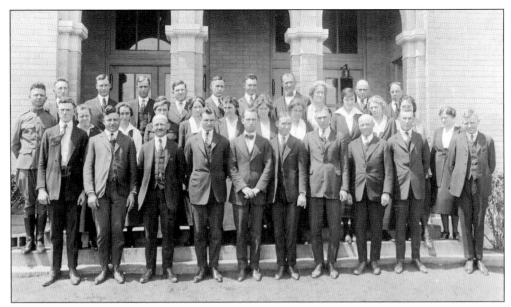

The entire faculty of Grubbs Vocational College for the first year was comprised of 14 people, including Dean Williams. They taught traditional college courses as well as vocational subjects such as agriculture, horticulture, rural economics, and domestic sciences. Together, they taught two years of secondary school work and two years of college to students as young as 14. By 1920, the faculty had doubled as evidenced in this photograph in front of the new administration building.

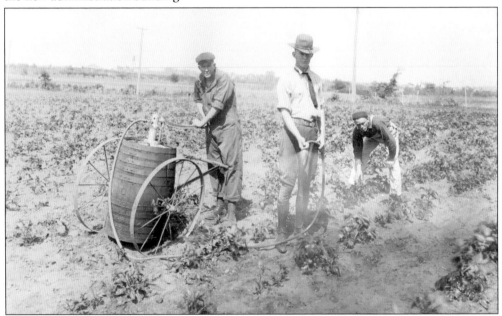

Initially, at the college level, students had two choices: agriculture for the men and household arts for the women. The curricula paralleled the parent institution, Agricultural and Mechanical College of Texas, to make it easier for male students to easily transfer to take advanced college courses. The focus was upon offering opportunities for students, like the ones spraying potatoes in this photograph, to learn the latest agricultural practices.

The new college should have been attractive to students because it was between two major cities and did not even charge tuition. Only 66 students signed up the first semester, a disappointing number that was perhaps due to the nation entering World War I and the young men being drafted to fight. The struggle to build a successful school included instituting machine shop classes to attract male students.

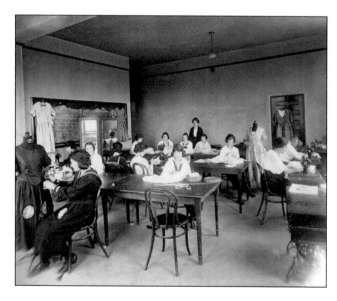

For the fashionable coed entering Grubbs Vocational College in 1917, back-to-school basics included Butterick pattern No. 9372 and several yards of gingham. Her first classroom assignment was to sew two dresses, estimated cost of $2, to wear as part of the school's uniform. Boarding students were required to wear the uniform on all occasions, while those living in town only had to wear one while on campus.

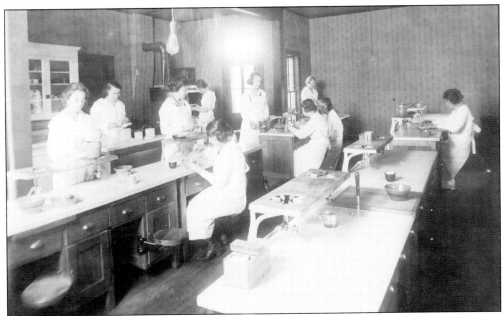

Female students living on campus were also responsible for planning, cooking, and serving their own meals as well as keeping the dormitory clean. Instruction in cooking was done in this lab. The 1917 *Bulletin of the Grubbs Vocational College* lists this program as practical instruction in the economic and scientific phases of housekeeping. For female students, perhaps the most attractive benefit was a $2 savings on the cost of room and board.

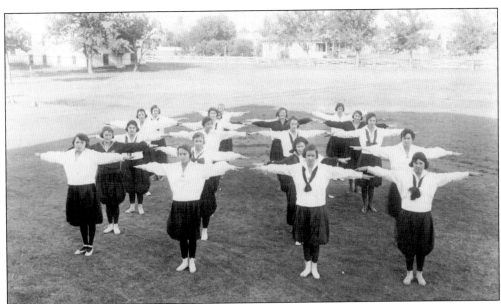

Grubbs Vocational College maintained military discipline and required both male and female students to wear uniforms and take courses in physical training. The young women in this photograph are participating in the hour of physical exercise required each school day. Sports also played an important part; the school sponsored a basketball team for female students.

In 1918, the college formed the Student Army Training Corps (SATC). SATC students registered for the draft and were inducted into service as SATC privates while in college. These SATC students would have received Army pay but would not have seen active duty in Europe because the war ended in 1918. The entire campus supported the war effort by buying Liberty bonds and war-tax stamps, making surgical dressings, and conserving food.

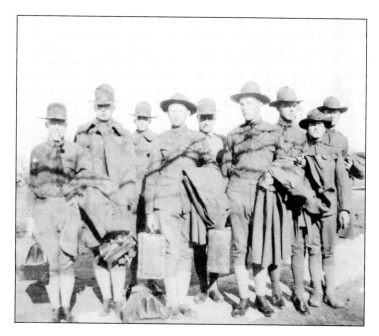

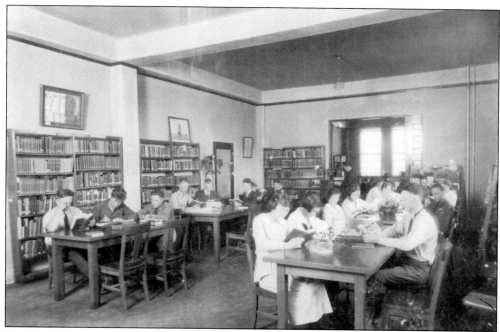

Enrollment for the 1918–1919 year increased dramatically with 192 students, mostly young men. Williams responded by enlarging the campus; building a mess hall, auto shop, and machine shop; refurbishing old buildings; increasing faculty; and adding courses. Campus life flourished, and students used the library in the new administration building for study. As enrollment increased, the state began reducing appropriations, so the college began levying higher fees on students.

The school sponsored a variety of clubs and organizations designed to enrich student life. The unidentified students in the Glee Club standing in front of the administration building could also play football, baseball, basketball, tennis, or track, as well as choose from the Wilsonian and Star Literary speaking and debating societies and the Dramatic Club. Women could join the Chorus Club, Roundup Club, and Gro-Voco Club, or play on the basketball team.

In April 1919, the students published a magazine called the *Shorthorn*, which replaced the *Grubbonian*, an earlier publication that only came out once. Dean Williams offered a prize of $2.50 in a contest to name the fledgling magazine. Students selected *Shorthorn* over KornKob, Swat News, Horse Sense, Grubworm, and GVC Shots. The unidentified *Shorthorn* staff in this 1920 photograph offered students sports news, poetry, and information on activities at a bargain $1.50 a year or 25¢ per issue.

The first issue of the *Shorthorn* features a target with a shorthorn steer in the center. The paper, published under the guidance of faculty advisor Thomas E. Ferguson, contains 48 pages, measures six by nine inches, and consists of two stories. After the first issue, 100 percent of students and faculty subscribed.

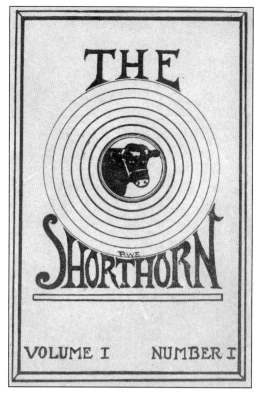

The *Shorthorn's* first editor-in-chief was Nathaniel Kilough, a Dallas farm boy and member of the Wilsonian Literary Society. During the early years, stories for the magazine were placed in a box in the college's main hallway. The magazine was so successful that the school changed publication from monthly to weekly in 1922. The newspaper remains one of the oldest traditions and has changed from weekly to daily. Today, it is published daily online with a print issue circulated on Wednesdays.

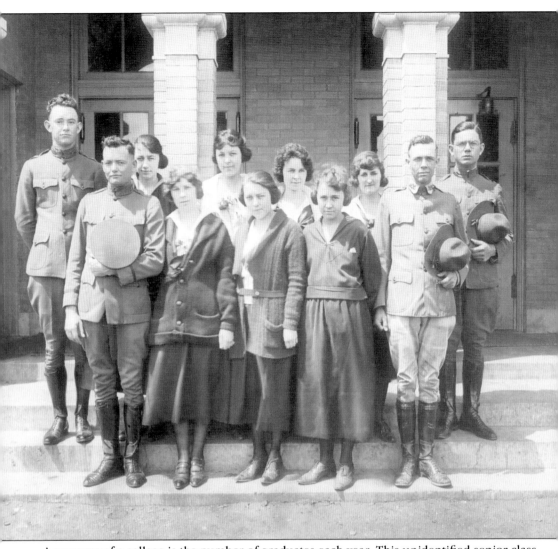

A measure of a college is the number of graduates each year. This unidentified senior class was part of GVC's success story. The school went from no graduates the first year to 23 in 1923. A second gauge of success is enrollment. Again, the college showed marked improvement, from 66 students in 1917 to 808 in 1923. During Grubbs Vocational College's six years of existence, Williams modified the curriculum from an initial focus on agriculture and household arts to a broader, more competitive program. Also improved were the school's buildings and grounds. Dean Williams, with the support of President Bizzell, felt that it was time for another, more important step. They wanted to change the name of the college. Williams thought that the use of *vocational* in the school's name limited the possibilities for the college and that Grubbs Vocational College sounded as if the college were privately funded. In July 1923, the Texas Legislature changed the name of the school to North Texas Junior Agricultural College. The name was shortened when the word *junior* was dropped, and the school became known as NTAC.

Three

A SENIOR COLLEGE AT LAST

The year was 1923, and the major topic of the news was the Teapot Dome scandal, widely regarded at the time as the greatest and most sensational scandal in the history of American politics. Even with such monumental headlines in the newspapers, the citizens of Arlington and surrounding counties were celebrating the first semester of North Texas Junior Agricultural College, soon to be called NTAC. The two-year college was to successfully navigate the worst of the Great Depression and the hardships of World War II. Students behavior was regulated on campus with demerits given for breaking rules. Life on campus was lively with dances, sporting events, and clubs. Dean Davis unsuccessfully petitioned several times to elevate the school to a senior college. The challenge was taken up by Dean Ernest H. Hereford when he was named the first president of the college in 1948.

In 1949, the school changed its name to Arlington State College (ASC) to signify that agriculture was no longer a major part of the curriculum. During the next decade, Arlington State College became the largest state-supported junior college in the Southwest and proudly promoted the comprehensive programs that had replaced the vocational courses of its predecessor. Now known as the Rebels, the football team won the Junior Rose Bowl in both 1956 and 1957. After much debate and the threat of action from the National Association for the Advancement of Colored People (NAACP), the college became the first in the A&M System to integrate, accepting African American students in 1962. President Hereford died after a decade of service to the school, and successor Jack Woolf led the school in its efforts to leave the A&M System and join the University of Texas System. As the school's student body grew from 1,532 to 11,000, the leaders of ASC began to believe that the school's interests and those of A&M were different.

Dean E.E. Davis arrived on campus in summer 1925 with a no-nonsense attitude toward renewing a sadly deteriorating physical plant, ridding the student body of students that lacked esprit de corps, and purging the faculty of incompetents. He began a 20-year building program and, with difficulty, built a new library (now College Hall) and a science hall (now Preston Hall) during the 1920s. His stern requirement of high scholarship standards and behavior resulted in 102 of 456 students leaving or being expelled due to bad grades or infractions during his first year. He replaced more than half of the 40 faculty members with younger, energetic, and relatively inexperienced teachers. Before he retired in 1945, Davis led the college through the Great Depression, World War II, and positioned the school for yet another major step, to becoming a four-year college. Davis Street is named in his honor, and Davis himself planted the grove of pine trees at Davis Street and Park Row Drive.

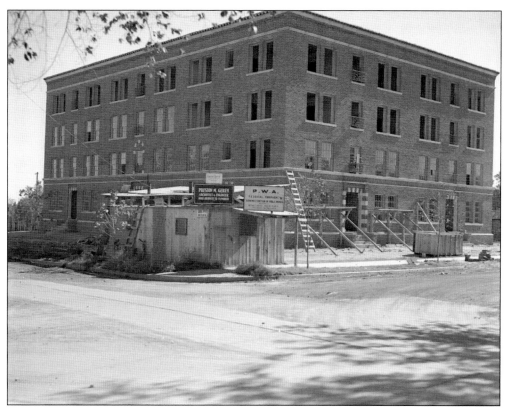

Davis Hall, now named Brazos Hall, was one of two new buildings constructed during the 1930s and was built with federal money through the Public Works Administration. Completed in 1936 and initially a men's dormitory, it is now the second-oldest building on campus and the first residence hall in the state of Texas to offer coeducational living.

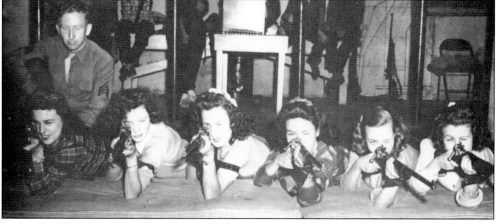

At the end of the 1930s, NTAC was successfully recovering from the Depression when Europe entered World War II and the United States followed after the attack on Pearl Harbor in December 1941. The college once again faced declining enrollment as students and faculty enlisted. The focus of NTAC changed to support the war effort and even included creating a young women's rifle team.

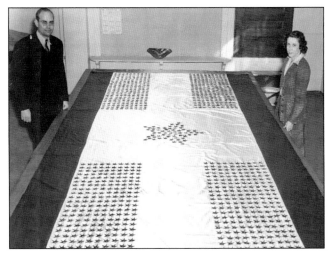

NTAC, as well as the nation, strove to support the war effort during the first half of the 1940s. Pride in the military service of former students and faculty members is reflected in the 1,056 stars on the flag created by the Home Economics Department in 1942. Harrison "Hoss" Dunsworth, secretary of the EX-Students Association, stands opposite an unidentified woman near the 17-foot-by-7-foot-wide flag.

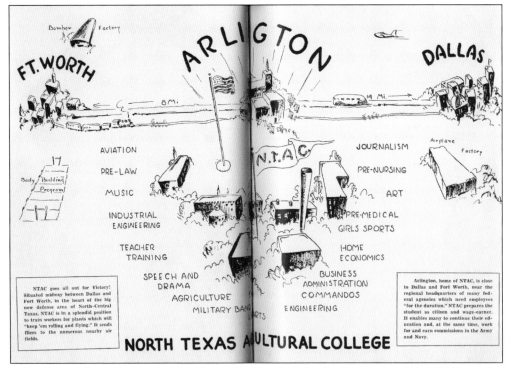

"NTAC goes all out for Victory!" exclaims the North Texas Agricultural College 1942 catalog in a dramatic two-page illustration. The school was ready to train workers for plants that would support the war efforts. NTAC is given pride of position on the page between Fort Worth and Dallas, cities that held many federal agencies needing employees.

The 1942 yearbook, *Junior Aggie,* promotes the industrial aeronautical engineer course that trained students as aircraft mechanics. More than 1,000 had been trained since 1929. Three Army contract flying schools had offered to hire all 62 students in the 1942 class. Sophomores, from left to right, Clyde Pratt, James Littlefield, and Norris Norman repair an airplane engine.

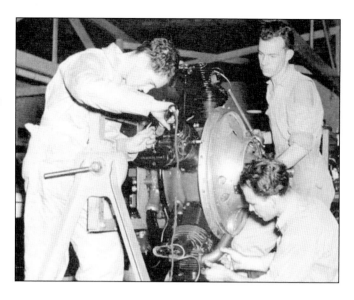

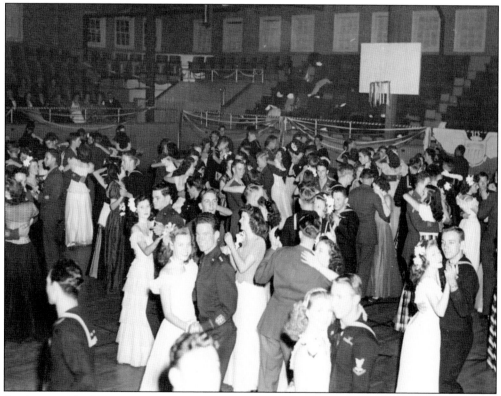

On August 14, 1923, Texas A&M President Bizzell wrote to Dean Williams that the school's military organization was now officially part of the Reserve Officers' Training Corps (ROTC). ROTC was mandatory for all male students until 1954, and the cadets in this 1947 photograph are enjoying one of the many dances given during the school year. That evening, they danced to waltzes and foxtrots wearing military uniforms while their dates glided in their arms wearing long gowns.

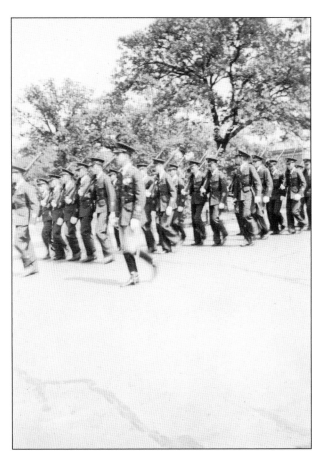

The Reserve Officers' Training Corps (ROTC) was born when Pres. Woodrow Wilson signed the National Defense Act of 1916. Since its introduction to NTAC, the corps has provided leadership and military training. The ROTC students marching in this 1937–1938 photograph would have been future commissioned officers in the United States Army.

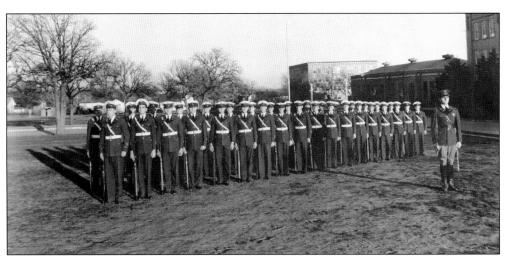

The Sam Houston Rifles, also known as "Jodies," were formed in the fall of 1924 out of the Cadet Corps of North Texas Agricultural College. The 1935 team is shown here on the parade ground once located in front of what is now Ransom Hall. A Rifles team performed at the Presidential Inaugural of 1957. The drill team currently has a winning average of over 91 percent in competitions.

Attending a junior college under Texas A&M, NTAC students were nicknamed Junior Aggies and the school was known as Northaggieland. This Junior Aggie is rushing to NTAC, 6 miles away, where the NTAC fight song was "Northaggieland," written by band director Col. Earl D. Irons and Enid Eastland. The school band proudly played the song at each score by the Hornets, the school's team. The NTAC Hornets played in a stadium located where the Maverick Activities Center is now.

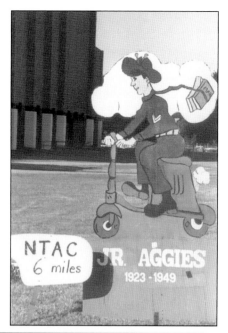

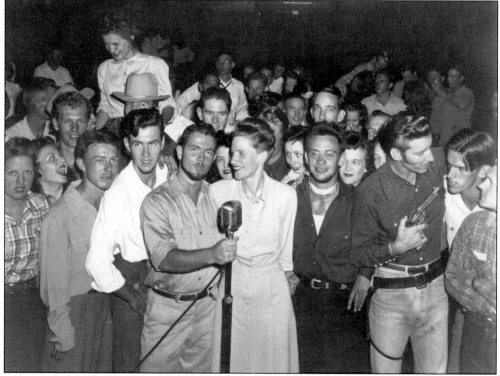

"How-w-w-DEE-E-E-E! I'm jes' so proud to be here!" declared Grand Ole Opry star Minnie Pearl in 1947 to the students attending a Western dance in the NTAC gymnasium. She is easily identified in the center with Jerome Jordan, the second-place winner in the whisker-growing contest, who is holding the microphone. At the lower right, Tommy Woodward is laying down the law to an unidentified student.

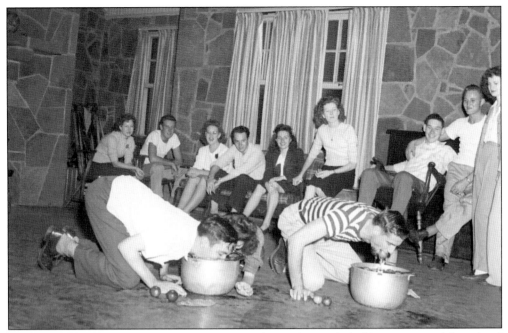

NTAC students enjoyed simple parties such as this 1940s apple-bobbing contest. The school had a variety of clubs and groups that met to share hobbies, fellowship, or joint interests. Many of these clubs formed the basis for fraternities and sororities when ASC joined the University of Texas System.

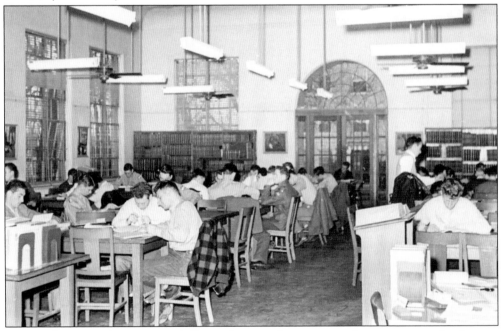

Despite the many chances to socialize and engage in sports, students came to school to get a degree. This required studying. The library was a popular place in 1947 for students to prepare for classes. Monday through Friday, lectures were scheduled for the morning and labs in the afternoon.

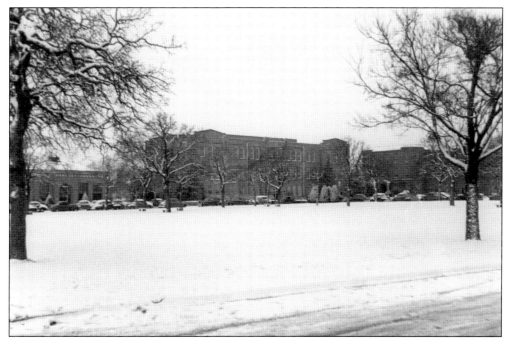

A rare snowfall on campus during the winter of 1947 made studying inside even more attractive. The view across the parade ground shows, from left to right, what are currently known as College Hall, Ransom Hall, and Preston Hall. These buildings form what is now the heart of the campus.

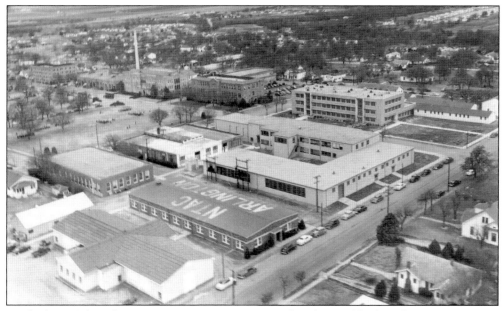

By the late 1940s, the NTAC main campus occupied eight city blocks. The street near the bottom is Cooper Street, a busy thoroughfare that is now below grade through much of campus. The parade grounds, shown at upper left, now hold the E.H. Hereford University Center and Woolf Hall.

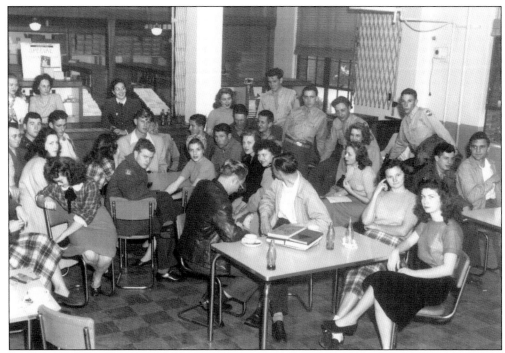

College Hall, constructed in 1926, held both the library and the NTAC Exchange Store (PX). The PX sold school supplies, military uniforms, and accessories. The store, shown here in 1948, served as a popular gathering place for students and faculty between classes, while the library was used for studying. Today, the Honors College is located in College Hall.

Howard Joyner arrived at NTAC in 1937 as part of a plan by Dean Davis to establish an art department before the University of Texas had one. Joyner had studied at the École des Beaux-Arts in France and was head of the art department at the University of South Dakota before arriving at NTAC. He is credited with developing the school's art department. In 1969, the university created a bachelor of fine arts degree, one of Joyner's dreams.

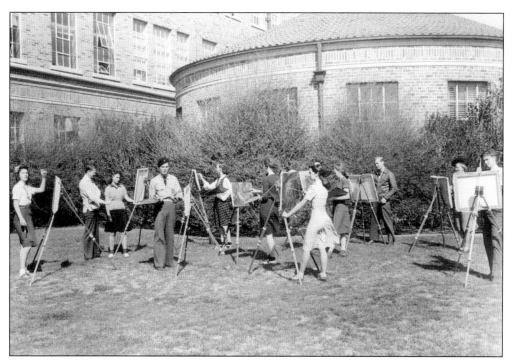

Built in 1928, the circular building on the south side of Preston Hall has had many functions. It has been a cattle show room, art studio, offices for the History Department, an art printing lab, and UT Arlington's main planetarium. Joyner taught students the art of camouflage there during the war. His students are shown painting landscapes in front of the building in this 1940s photograph.

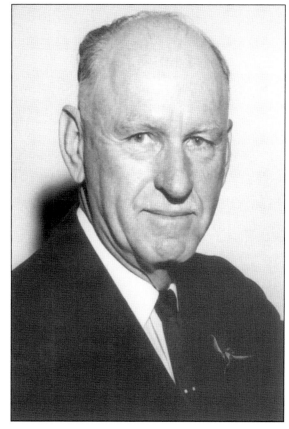

Ernest H. Hereford was appointed NTAC's first president in 1948, shortly before the school became Arlington State College. During his 10-year tenure, enrollment nearly quadrupled and several buildings were constructed, including the student center that bears his name today. Hereford was fondly known as "Old Rosebud" because he always wore a rose in his lapel. The Rosebud Theater inside the student center was named in honor of his love for roses.

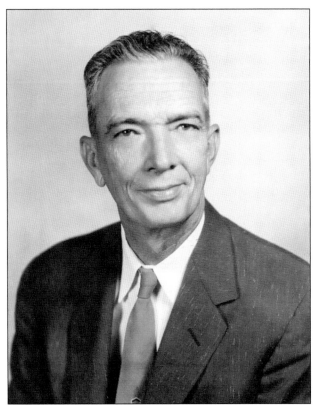

Duncan Robinson came to NTAC in 1928 to teach a few courses as well as coach the debate team, organize a literary society, sponsor student publications, and serve as the college public relations official. He remained to do much more. He and NTAC Dean Davis would go to East Texas to recruit students, and every Christmas, Robinson would read Charles Dickens's *A Christmas Carol* to enthralled audiences.

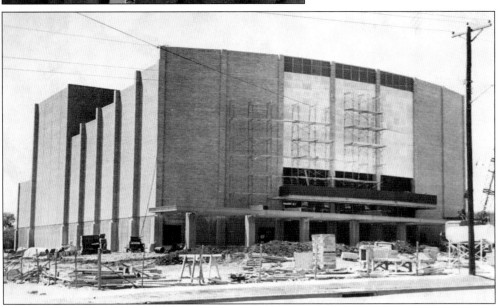

The concrete walls and scaffolds in this 1964 photograph of the future Arlington State College Multipurpose Auditorium do not hint of the building's remarkable contribution to campus history. The first performer in the new hall was legendary American jazz trumpeter and singer Louis Armstrong in 1965. Named Texas Hall in 1968, the auditorium is used for concerts, lectures, meetings, and theater and dance performances.

In 1949, when the North Texas Agricultural College transitioned to Arlington State College, the mascot became the Blue Riders, which did not catch on. President Hereford called a meeting of sophomores and asked them to suggest another mascot. Johnny Reb, representing a Rebel theme, won the student vote. Wearing his Johnny Reb outfit, Robert "Rusty" Russell takes a moment to pose in front of a float in 1965.

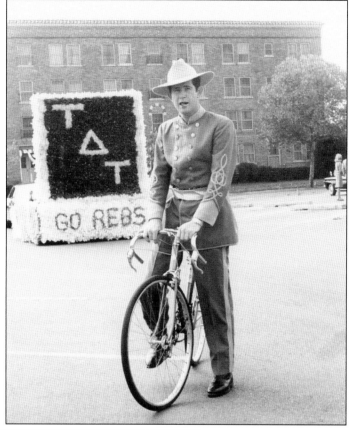

In 1958, when this banner was hung, Sans Souci was one of the many clubs and groups in the Texas A&M System. The name, which translates as "without a care," remained the sorority's motto from 1923 to 1968. Affiliation with Sans Souci ended when the Arlington State College became part of the University of Texas System and the Panhellenic Council opened the campus to national sororities. Members of Sans Souci pledged Alpha Chi Omega on November 17, 1968.

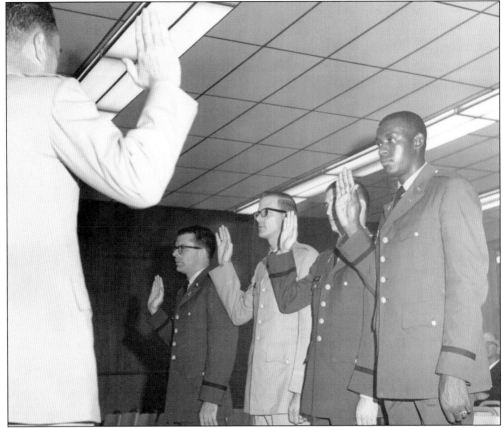

Standing at attention on the far right of the photograph, Oscar K. Chambers became the first African American ROTC graduate at ASC in August 1965. Joining him, from left to right, are Thomas M. Darnall, Douglas W. Spruill, and Eddie W. Osburn. All are part of the long and prestigious military tradition that started with the Carlisle Military Academy and continues today.

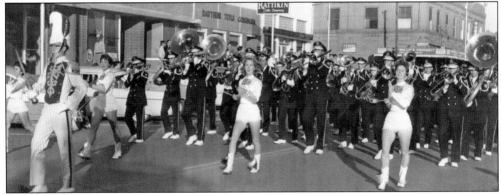

This 1960s marching band proudly parading down Arlington's streets exemplifies school spirit. The marching band has been a driving force in campus life, tradition, and spirit for over 100 years. Currently, it is the only college marching band without a football team in the nation. The band continues to perform in front of capacity crowds and captivate audiences of all ages throughout the country.

48

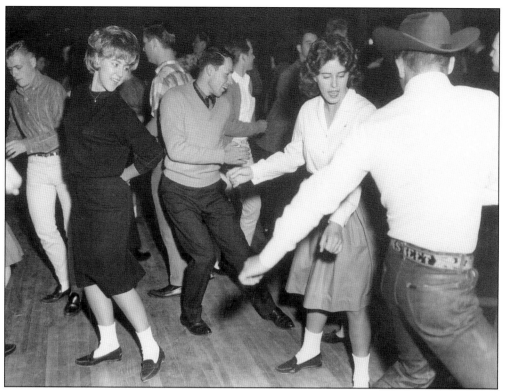

Dancing the twist, which became popular in the 1960s, ASC students are keeping up with the fashions. As in their choices for dance, they were also aware of employment trends and were choosing engineering, business, arts, and sciences rather than the agricultural and domestic sciences courses taken by earlier students.

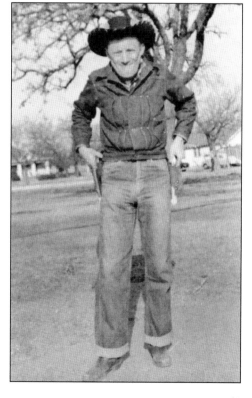

Known as "Little Marshal," Marshall Morton was one of the most beloved figures on the ASC campus during the 1950s. Recognizable in his boots, jeans, and shiny tin star, and wearing two cap pistols strapped around his waist, Marshall opened doors for coeds, helped the campus security guards, and participated at halftime during football games. Born with intellectual and physical disabilities, Marshall was a treasured part of campus life.

Jack Royce Woolf (left) was dean of engineering at Arlington State College and was appointed president of ASC after the death of President Hereford in 1958. The next decade was one of change, with the school earning four-year status, experiencing rapid enrollment and expansion, becoming the first university in the Texas A&M System to integrate its student body, and transferring from the Texas A&M System to the University of Texas System. During his administration, the school's Rebel mascot and Confederate theme personified by Johnny Reb (below) were challenged. After much controversy, the school's mascot became the Maverick. In 1968, Woolf resigned the presidency and became professor of engineering and higher education, retiring in 1989. In 1995, the university named the first of many buildings constructed during his presidency Woolf Hall.

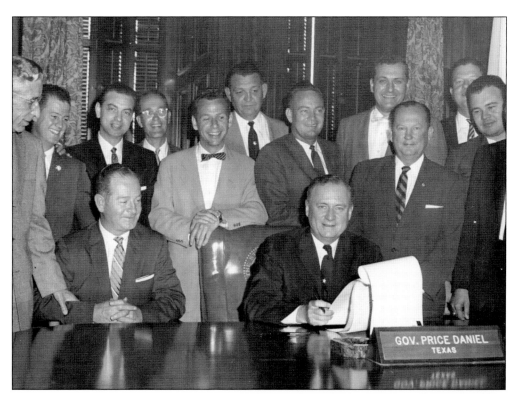

Arlington and ASC campaigned for four-year status for almost a decade. The school sent bills to the Texas Legislature in 1951, 1955, and 1957 without success. Dean Davis created lists of reasons why the school should be a four-year institution, including local need for skilled graduates and the school's ideal location. Finally, on April 27, 1959, Gov. Price Daniel, seated at right in the image above, signed the bill making ASC a four-year institution; Arlington's Mayor Tom Vandergriff (back and third from the left) looks on with unidentified individuals. When the news reached campus, classes were brought to an end while sirens and car horns spread the news. In the photograph at right, ASC cheerleaders Charla Blont (left) and Jerry Carter (right) join bandsman Ken Priksyl (center) in the revelry. The *Shorthorn* headline of April 28, 1959, declares "Made it at Last."

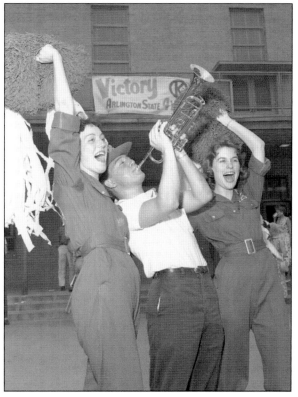

Civic leader Tom Vandergriff was one of the driving forces behind the transformation of ASC to a full university. He described the signing of the bill as "one of the most satisfying moments of my life." He later worked with Sen. Don Kennard to move Arlington State College from the Texas A&M System to that of the University of Texas in 1965. Vandergriff Hall at College Park is named after him.

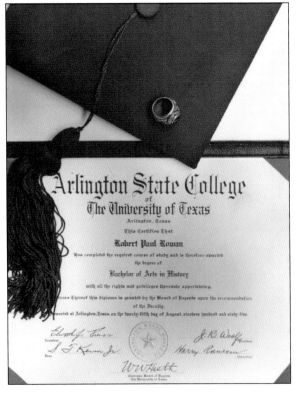

ASC's revised September 1959 catalog proudly announces that the college is adding courses for juniors in the fall and that it will have senior-level courses in fall 1960. Bachelor of arts graduate Robert Paul Rowan's 1965 diploma, cap, and senior ring are reminders of the school's triumph.

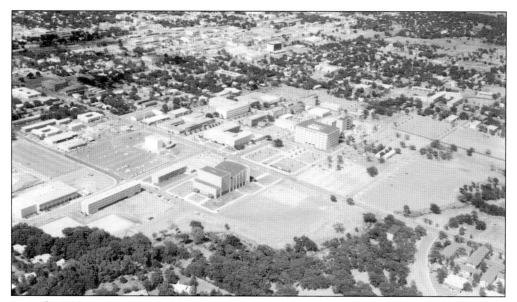

By 1967, ASC was surrounded by parking lots and known as a commuter school where an overwhelming number of students lived off campus. The majority of the student body was nontraditional—married and working. The school was meeting their needs with courses offering engineering, sciences, and other subjects that enabled them to keep up with a rapidly growing economy.

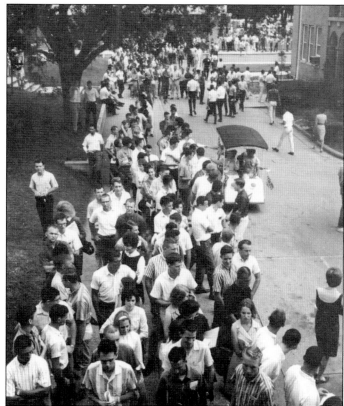

The crowd of students in this 1965 registration line reflects the rapid growth of the campus. Contributing to the development were senior college status, graduate programs, and rapid acquisition of land and accelerated building programs to support expansion. Individually and together, students would face the challenges posed by civil rights marches, protests against Vietnam, and counterculture revolution against conservative social norms.

As the school's enrollment grew from 1,532 to 11,000, the leaders of ASC began to believe that the school's interests and that of Texas A&M were different. It was felt that Texas A&M was not willing to invest sufficient funds to support ASC's rapid growth. Jack Woolf led the school in its efforts to leave the Texas A&M System and join that of the University of Texas. As the Texas A&M System considered changing the school's name and how degrees were issued, the *Arlington Citizen-Journal* comments in a 1964 editorial, "On first impression, we didn't like it. And after giving it some additional thought, we are ready to do battle." State representative Howard Green (pictured) declared in a speech, "I won't sleep through Congress if a bill to rename Arlington State College is submitted." The school was ready to fight.

Four

WE'RE TEASIPS NOW!

For almost 50 years, the college in Arlington belonged to the Texas A&M University System, but the relationship fell apart in the early 1960s. Fast-growing Arlington chafed at the laggardly pace of change from Texas A&M, particularly regarding the establishment of a graduate school and construction of new facilities. Simmering tensions erupted in December 1964 when Texas A&M suggested that Arlington State College be brought closer in the fold and have its name changed to Texas A&M at Arlington. At that, people openly began discussing a divorce between Arlington State College and Texas A&M.

A common refrain was, "If I wanted to be an Aggie, I would be going to Texas A&M," NTAC's proud use of the name Junior Aggies apparently forgotten. Separatists often noted that ASC had, in fact, outstripped A&M in enrollment and A&M only wanted to mine Arlington to shore up its own, then shaky, stability.

Within five months, the divorce was final. On April 23, 1965, Gov. John Connally signed a bill removing ASC from the Texas A&M System and placing it in the University of Texas System. Back in Arlington, students fired off the school cannon and drank free tea in celebration.

In 1967, Arlington State College became the University of Texas at Arlington. To this name change, there was barely a murmur of protest. UTA president Jack Woolf told the *Dallas Morning News*, "Finally, I think we have reached a name which does not shackle the future development of the institution. Opportunities which are now ours are boundless. Let us hope that this name will stick."

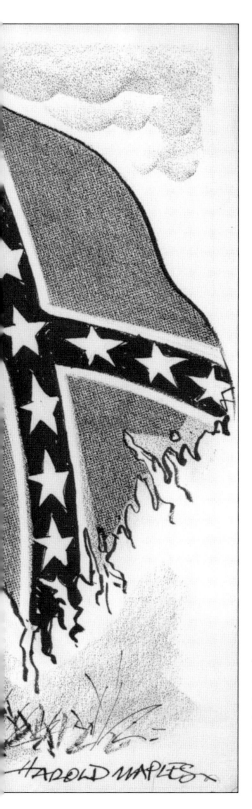

Gov. John Connally signed the bill removing ASC from the Texas A&M System and placing it in the UT System on April 23, 1965. ASC student body president Lynn Little stood on a desk in the governor's reception room and relayed events by telephone back to Arlington where they were broadcast over the public address system. When Connally lifted the pen, Little shouted, "He's signed it. It's over. We're teasips now!" "Teasips" was the name Texas A&M students called University of Texas students.

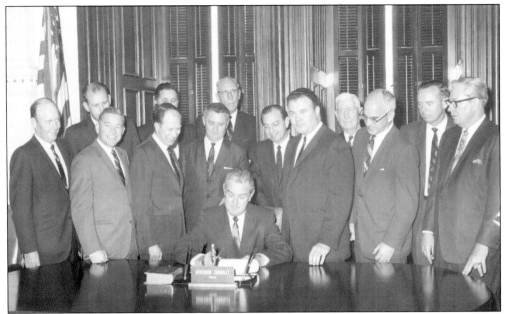

Pictured is Gov. John Connally (seated) signing the bill. Behind him on his left stands Arlington mayor Tom Vandergriff. In the front row of men, third from left, is ASC president Jack Woolf. Between 75 and 100 people witnessed the signing. Texas A&M's student newspaper, the *Battalion*, sour about the whole affair, predicted that ASC would "remain a second-rate college."

The campus celebrated upon hearing Little's pronouncement. Students fired off the school cannon and drank free tea in celebration. One professor compared the day to the Fourth of July and San Jacinto Day. "It's the finest display of student spirit since we went to the Little Rose Bowl last in 1957," professor B.T. Williams told the *Dallas Morning News*. "What can I say? Hook 'em Horns!"

British comedy hit UTA in March 1978 with Monty Python Day. The day included a silly walks contest, the Twit Olympics, and re-creations of Monty Python skits. The most popular event was bladderball. Raucous throngs scuffled the ball into Cooper Street (stopping traffic), and then into University Hall and Dr. Allan Saxe's political science class (halting that as well). The game was called after too many students dropped out, with each team declaring victory.

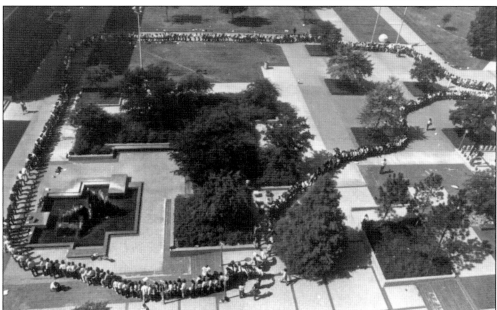

Metroplex college rivalry led UTA students to attempt to break the world record for lap sitting in October 1982. "UTA's really done nothing," said James Johnson in the *Shorthorn*. "You hear all the time on the radio and TV about SMU and TCU. We thought we'd prove something." Only 900 students participated. Still, the students had a good time. "We're emphasizing the fun," organizer Erin Cory said.

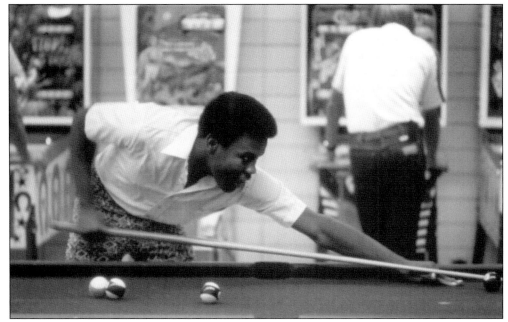

The E.H. Hereford University Center has been the student gathering space since its opening in 1952. In this undated photograph, students play pool and pinball. The UC has also housed a bowling alley and a saloon, the Dry Gulch, which closed in 1992. The UC has been expanded and remodeled several times over the last 60 years.

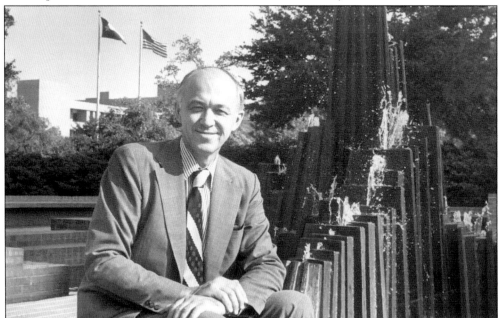

Wendell Nedderman served as UTA president from 1972 to 1992—a period of significant growth and maturation for the university. During his tenure, UTA added 64 degree programs and 24 buildings and went from 14,000 students to more than 25,000. "Somebody asked me once . . . what do I consider my greatest legacy?" Nedderman said in 2007 to *UT Arlington Magazine*. "My greatest legacy is that I was an honorable man."

Jane Fonda was still two years away from visiting North Vietnam when she came to speak at UTA in 1970, but she was already a controversial figure. Fonda spoke to students about the GI movement (an antiwar movement within the armed forces) and urged President Nixon's impeachment. The event was moved three times—from outside the student center, to inside the student center, and finally to Texas Hall—to accommodate the crowd of 2,500.

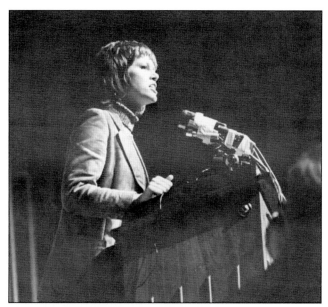

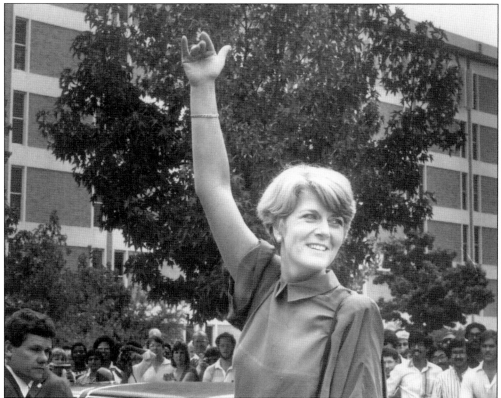

Democratic vice presidential candidate Geraldine Ferraro campaigned at UTA in September 1984. Between 4,000 and 5,000 people showed up to hear her speak about Reagan and the nuclear arms race, but about 400 protesters heckled Ferraro to the point where she had to momentarily stop her speech. After the crowd quieted, she quipped: "If I had a record like Ronald Reagan's, I wouldn't want anybody to hear about it either."

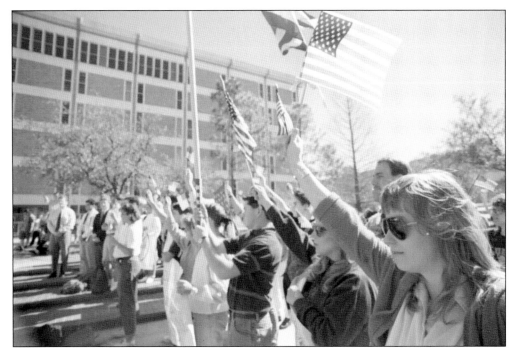

UTA showed its support of the United States' troops in Desert Storm with a rally on the Library Mall in February 1991. Weeks before, students organized an impromptu candlelight vigil after war was declared in Iraq. The atmosphere of support for US troops was a marked difference from Vietnam-era rallies.

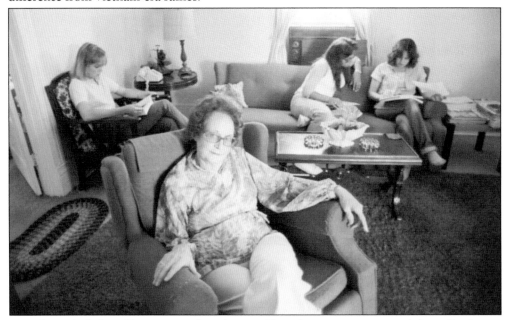

Providing a little bit of home away from home, Ellen Morgan ran a women's boardinghouse on Abram Street for UTA students from the mid-1960s through the 1980s. She cooked breakfast, lunch, and dinner during the week for the six boarders and always had a dessert. Chocolate cake was the general favorite of the house.

ASC dedicated a two-story library designed by George Dahl on May 10, 1964. University of Texas chancellor Harry Ransom called it "a punctuation mark in the development of Arlington State College." Four more stories were added to the building in 1967. "We thought it was a big deal when we got the four stories," said UTA president emeritus Wendell Nedderman. "That was uptown!"

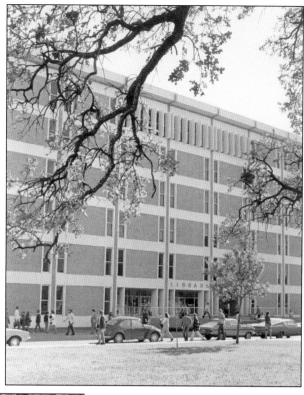

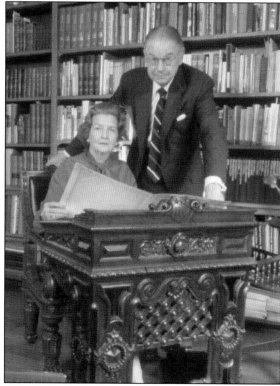

On March 3, 1974, Special Collections opened in Central Library with an incredible donation of over 10,000 books, documents, manuscripts, and other items by Jenkins and Virginia Garrett of Fort Worth, shown here in their home. The collection focused on the history of Texas, Mexico, and the Southwest. "Jenkins and Virginia Garrett are the greatest benefactors this institution has ever had," said Nedderman. "You can't put a price on it."

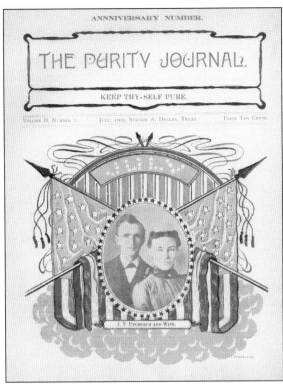

ANNNIVERSARY NUMBER.

THE PURITY JOURNAL.

KEEP THY-SELF PURE.

VOLUME II. NUMBER 1. JULY, 1905, STATION A, DALLAS, TEXAS. PRICE TEN CENTS.

J. T. UPCHURCH AND WIFE.

When driving through UT Arlington on Cooper Street, it is impossible to imagine that an area now covered by trees on campus was once the site of the Berachah Home for unwed mothers. The only hint of the past is the small tombstones in the meadow grass on the university grounds. The home was established by Rev. James Upchurch and his wife, Maggie (left). Their mission was to share their deep faith with the less fortunate and offer a place to nurture and train young women in skills such as nursing, printing, gardening, and home economics. Upchurch never reviled the girls who found their way to the home and did not regard the children born to unwed women (below) as illegitimate. Unlike many such institutions at the time, Berachah Home required the women to keep their children and did not allow adoption.

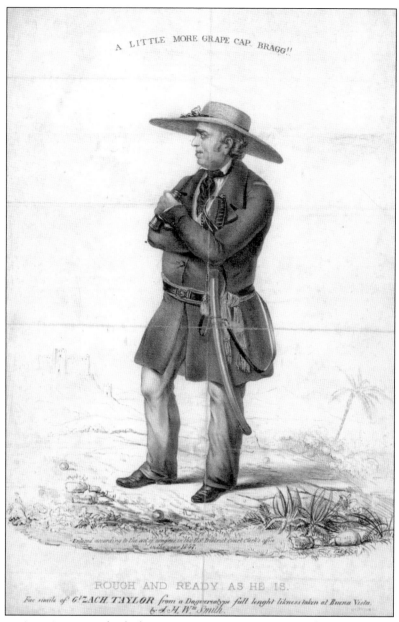

A LITTLE MORE GRAPE CAP. BRAGG!!

ROUGH AND READY, AS HE IS.

Fac simile of Gᶦ ZACH. TAYLOR from a Daguerreotype full lenght likness taken at Buena Vista.
& A. M. Wᵐ. Smith.

While many Americans overlook the Mexican-American War (1846–1848), the impact that it had upon the United States is still evident today. Pres. James Polk's ambitions to continue the nation's expansion to the Pacific coast with the acquisition of New Mexico, California, and part of northern Mexico was a result of the idea of Manifest Destiny. The United States and many of its citizens believed that the nation was destined to expand shore to shore on the continent. Many military leaders in the war with Mexico later served on both sides of the Civil War. Indeed, the political ramifications of whether the new territory would permit slavery contributed to the Civil War. UTA Libraries Special Collections offers researchers access to both the American and Mexican points of view with books, maps, broadsides, government documents, newspapers, and graphics such as this one of "Old Rough and Ready," Gen. Zachary Taylor.

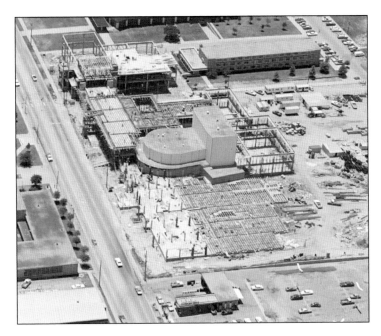

Students called it "the Jolly Green Giant's john," but its official name was the Little Theater. As told in *UTA Magazine*, some members of Alpha Phi Omega got together in 1967 and built a 12-foot toilet handle out of boards, cardboard, and silver spray paint, then hung it from the roof. Called Mainstage Theater today, the building is surrounded by the Fine Arts building, shown under construction in 1973.

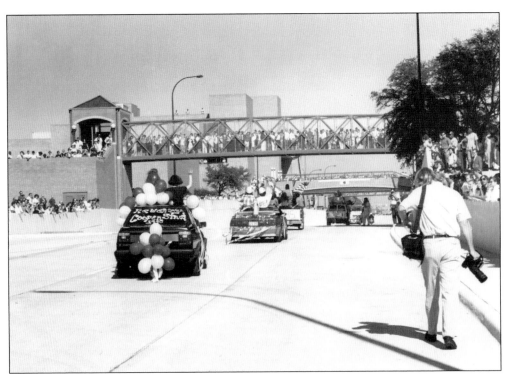

Students in the 1980s called Cooper Street "Frogger's Alley" after the video game in which a frog must cross a street of busy traffic without getting squashed. But after wheelchair athlete Andrew David Beck was killed trying to cross, the university, city, and state began working to lower the road and build pedestrian bridges. The campus celebrated the project's completion with a parade in November 1990.

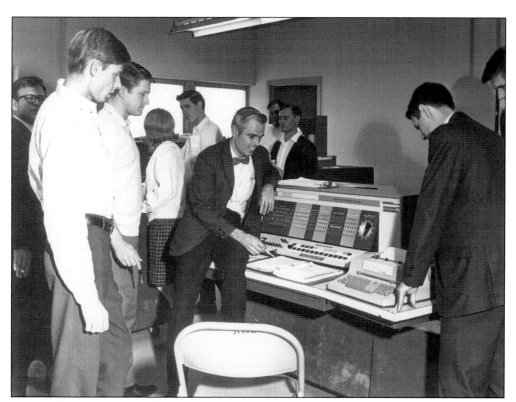

Industrial engineering professor Melvin Pierce demonstrates an IBM 1620 to UTA students in 1968. The IBM 1620, described as desk-size in its advertising, was widely used in schools for engineering programs. Pierce, who was hired in 1961, was a leader in computing at UTA and eventually became the director of computer development.

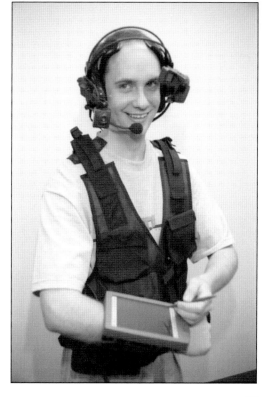

In these days of the slim iPhone and Google Glass, the 2000s version of wearable computers seems awkward and ungainly. Still, this wearable technology was remarkable for its time and confirmed UTA's position as having a top-ranked computer science program in the United States, according to a 1998 National Science Foundation report.

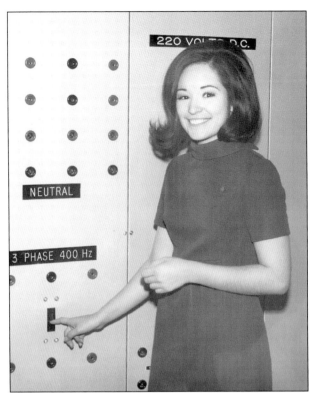

Since becoming a four-year college in 1959, UTA had no female electrical engineering graduates until Linda Garza graduated in 1970. "I'm glad I went to Arlington," Garza told the *Irving Daily News*. "The faculty treated me just like any other student." After graduating, she joined Dallas Power and Light Co.

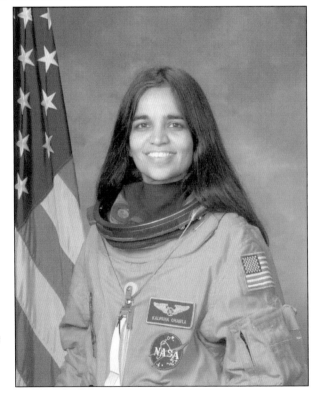

Born in Karnal, India, Kalpana Chawla came to UTA and earned her master's degree in aerospace engineering in 1984. She joined NASA in 1994 and flew on the space shuttle *Columbia* in 1997—the first Indian woman to go into space. In 2003, she again flew on *Columbia* on a mission that ended in tragedy when the shuttle broke up over North Texas during reentry. A residence hall and scholarship are named in her honor. (Courtesy of the National Aeronautics and Space Administration.)

As news of the September 11, 2001, attacks broke, students gathered around campus television sets and radios to watch, listen, and cry. The campus sent an e-mail announcing the cancellation of classes but retracted the statement just 11 minutes later. Many distraught professors and students decided to cancel classes anyway. Shortly after the attacks, UTA brought the campus together to remember and honor those killed.

UTA alumnus Gen. Tommy Franks led the attack on the Taliban in Afghanistan after the September 11 attacks on the World Trade Center and the Pentagon in 2001. He later led the 2003 invasion of Iraq. Franks, who also served in Vietnam and the first Gulf War, graduated from UTA in 1971 with a degree in business. Franks (left) is shown with UTA president James Spaniolo.

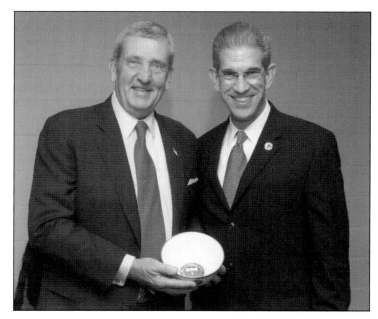

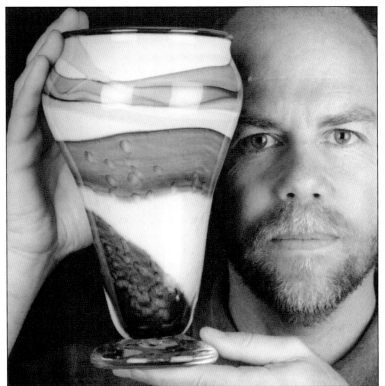

David Keens came to UTA in 1974 as a metalworker, but when the school bought some basic glass-blowing equipment, his destiny changed forever. "Here I was, working alone, hunched over a piece of metal for a month or more," he told the *Fort Worth Star-Telegram*. "But glass was quick, spontaneous, and when it was done everyone applauded." Keens, named Texas State Artist in 2007, retired from UTA in 2013.

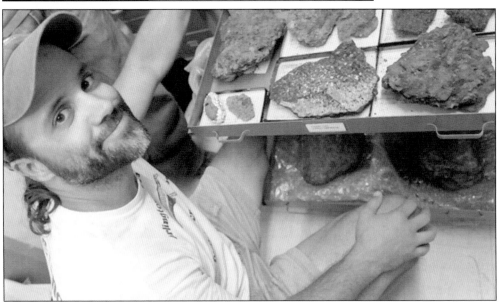

Dinosaurs in Arlington? The thought brings to mind a cable-television knock-off of *Jurassic Park*. But Arlington is home to a unique, urban cache of dinosaur fossils from the Cretaceous period. The Arlington Archosaur site was first discovered in 2003, but excavations did not begin until 2008 under the leadership of UTA paleontologist Derek Main (1971–2013), pictured. Today, the fossils are housed at the Perot Museum of Nature and Science. (Courtesy of the University of Texas at Arlington.)

The University of Texas at Arlington College of Nursing has roots in one of the oldest schools of nursing in the Southwest and offers programs ranging from bachelor's degrees through the doctoral level. Although the college is known for its technologically enhanced classrooms, faculty members like John Reed, seated to the left in his classroom, and others still continue to offer personalized support to students.

Professor, pundit, and philanthropist Allan Saxe has worn many hats since his arrival at UTA in 1965, but it is his everyday philanthropy that makes him a hero to thousands. Over his lifetime, he has donated hundreds of thousands of dollars to charities and the arts, all on his professor's salary. (Courtesy of Evelyn Barker.)

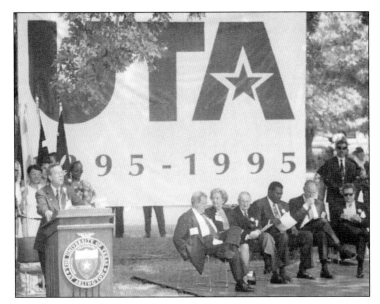

"We suggest, with all due respect to General Motors, that UTA is the heartbeat of Arlington," said Pres. Emeritus Wendell Nedderman at the August 1995 kickoff for the university's centennial. The yearlong celebration highlighted how far the university had come from its origins as a struggling rural school to its status as the second-largest university in the UT System.

College Park Center, home to basketball and volleyball teams, opened February 1, 2012, to jubilation and accolades. "You know, Toto, I don't think we are in Kansas anymore," UTA president James Spaniolo said. The first events in the new arena were the women's and men's basketball teams playing against University of Texas at San Antonio. (Courtesy of the University of Texas at Arlington.)

Five

REBELS AND MAVERICKS

The university archives tell the story of the campus's most divisive issue in its long history: the use of the Confederate flag as part of the school's theme along with the Rebels as the school's mascot. Arlington State College (ASC) had selected the Rebels as its mascot to replace the lackluster Blue Riders. Once the mascot was determined, it was natural for other motifs of the Confederacy to appear. Band uniforms sported a large Confederate flag. "Dixie" became the fight song. None of this was a problem for the all-white student body; however, once ASC integrated, the campus newspaper editorialized that the Confederate theme was no longer appropriate.

Little changed until 1965 when the school became part of the UT System and the *Shorthorn* once again argued that "ASC should break even more ties with the past, changing the school spirit theme from the Rebel Dixie motif." Throughout the following five years, students on campus protested, voted, and struggled with the school's Confederate theme. Student Congress removed the Confederate flag from the student center in July 1968, but the battle was just starting to rage in earnest. The university administration consistently handed the decision to change the theme to the students; however, they were unable to find a solution. On January 29, 1971, the UT System Board of Regents voted to abolish the Rebel theme. The students held a vote in April 1971 for a new theme. After votes and runoffs, a winner was finally declared: Mavericks. The school mascot has experienced many changes, but from this period of strife and upheaval came the most enduring mascot the university has ever had—Mavericks.

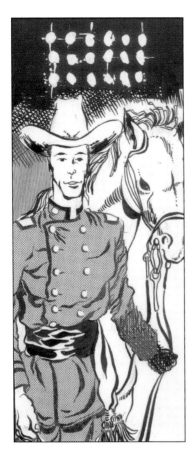

In 1951, Arlington State College embraced the romanticism of the Deep South by choosing Rebels as the college's mascot to replace the lackluster Blue Riders. In this cartoon, Johnny Reb with his steed exemplifies the Rebel spirit.

Once the mascot was determined, it was natural for other motifs of the Confederacy to appear around that theme. Band uniforms sported a large Confederate flag and "Dixie" became the fight song. Student Congress flew the Confederate flag outside of the student center. During the 1966–1967 school year, Kenny Terry and Donna Vee Owens, holding a Confederate flag, represented Mr. and Mrs. Rebel Spirit.

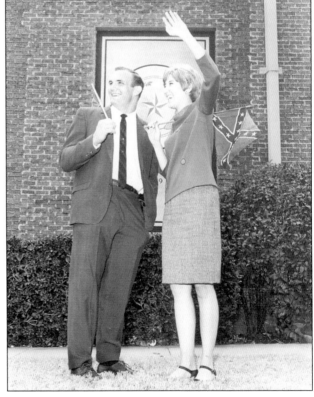

Homecoming week was called Old South Week. Some groups held mock slave auctions, and the celebrations included the election of Johnny Reb and Miss Dixie Bell. Scotty Nicholson (Johnny Reb) and Jackie Moe (Miss Arlington State College) pose behind furniture in the E.H. Hereford Student Center. The upholstery is covered with portraits of Confederate heroes and slaves working in fields.

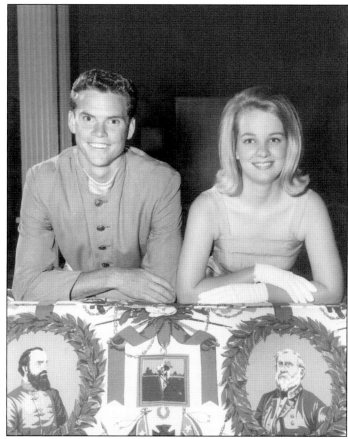

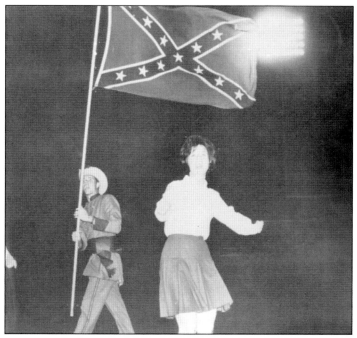

In 1962, ASC peacefully integrated. That same year, the campus newspaper, the *Shorthorn*, editorialized that the Confederate Rebel theme was no longer appropriate. However, the Confederate flag and Rebel theme continued to be a part of the ASC traditions. Scenes such as this Johnny Reb with the Confederate flag were common.

In May 1965, the campus held the first of what would be many referendums on the school's theme. Students voted to keep the Rebel theme, but the battle was now engaged. This undated photograph of the UTA Rebel Headquarters on the back of a truck exemplifies the passion that many had for the Rebel theme.

In October 1965, a group of 25–30 students (including eight or nine African Americans) staged a peaceful protest under the Rebel flag to oppose the Confederate theme. After singing "Freedom" and "We Shall Overcome," the protesters got into a heated discussion with pro-Rebel students. It was common to see students both for and against the theme at pep rallies such as this one attended by Theodore Smith (left).

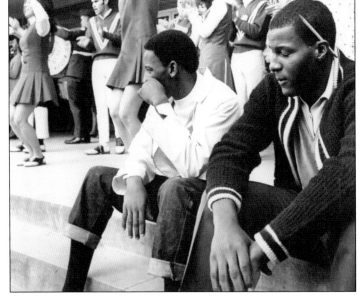

Writing in the spring 1966 *Arlington Review*, African American student Henry Adkins (right) says, "I had never really thought of the Rebel theme at Arlington State as degrading to my race because it was never looked upon as a racial issue. But as I began to think of the Confederacy and the Rebel theme 'Dixie' of the deep southern states that look upon the Rebel flag as some sort of sacred heritage, I began to wonder if such a nice school should have such an evil (in my opinion) associated with it." Student Congress removed the flag from the student center in 1968, UTA Campus Policeman Mark L. Britain (below) lowered the Confederate flag for the last time. The flag never flew again, but the battle over the Confederate theme was just starting to rage in earnest.

Although publicly calling for the end of the Rebel theme, university administration consistently handed off the decision and responsibility to change the theme to the students. Acting university president Frank Harrison wrote to Collegiates for Afro-American Progress (CAP): "A change in the theme will be recommended by the administration to the appropriate authorities only if supported by a majority vote in a legal referendum of the students."

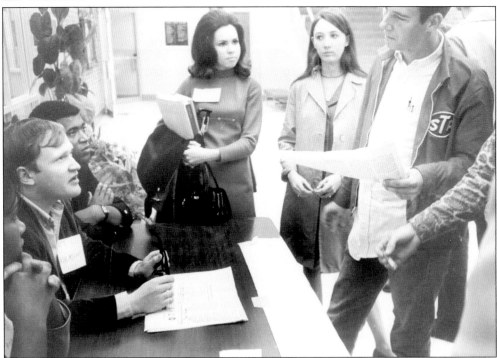

In spring of 1968, Student Congress passed resolution No. 132, which called for the end of the Rebel theme. This prompted a backlash from letter writers who called the members of the Student Congress un-American and destroyers of school tradition. Student discussions, such as the one captured in this 1968 photograph, engaged students both for and against the Rebel theme.

In November 1968, Student Congress put the theme issue to a campus-wide vote. Alternate mascots included Aardvarks, Texans, and Mavericks. Jerry Cripps posed as Johnny Aardvark during the 1968 Homecoming parade. Of the 4,497 students that voted, more than 3,500 of them wished to keep the Rebel theme. The students had spoken; to do otherwise than to uphold the Rebel theme would be to subvert democracy.

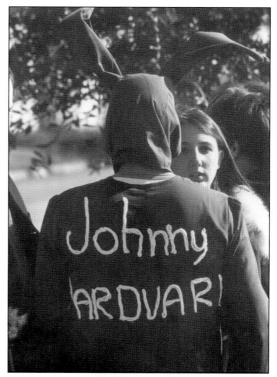

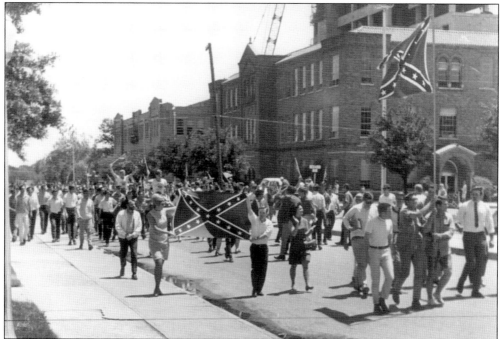

Why was the Rebel theme so popular? Peaceful advocates for the Rebel theme are shown marching past Ransom and College Halls during the spring of 1968. When interviewed by the *Shorthorn* in 2000, Kenny Hand said, "To white kids like myself, it wasn't a symbol of racism at all. It was just a symbol of the South and a symbol of the school."

In 1966, three unidentified Avolonte (Zeta Tau Alpha) pledges in blackface are participating in Old South Days. Such Confederate and Southern traditions were being challenged during an era of social change across America.

Far from bringing an end to the matter, Student Congress planned a March 1970 vote to pit Mavericks against Rebels. By this time, the UT System Board of Regents had joined the fray and passed a rule mandating the use of the Texas state flag as the official flag for each institution in the UT System. UT Arlington students, both for and against, had the opportunity to express their opinions in pep rallies such as this one led by head cheerleader Frank Prochaska.

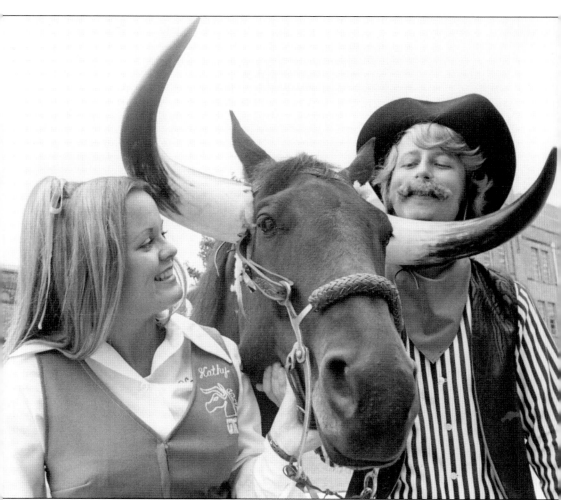

On January 29, 1971, the UT System Board of Regents voted seven to two to abolish the Rebel theme, effective June 1, 1971. In May 1971, after an election and runoff, there was a clear winner: Mavericks. The obvious question was, "What is a Maverick?" An unbranded cow? A wild horse? A freethinking, independent person? No one at UT Arlington knew, so a committee of students and administrators solicited sketches from artists around the area. After yet more voting, the students chose a horned horse. Imagination and creativity resulted in a horse wearing a bridle with cow horns attached. Unfortunately, illustrations of the horse in profile only showed one horn, and many students thought that their mascot was a unicorn. Kathy Marcum and Kirk Walden, representing Sam Maverick, pose in this undated photograph holding a somewhat unhappy horse, a Maverick.

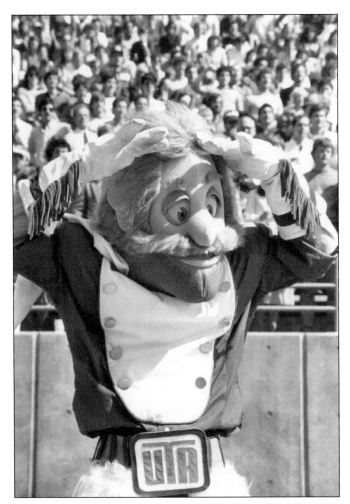

The horned horse did not last. For one thing, horses—horned or otherwise—were not allowed on the field of Arlington Stadium. So a Maverick became Sam Maverick, loosely based on the historical Samuel Augustus Maverick, a Texas land baron and legislator. Sam Maverick endured into the 21st century with various makeovers, the last coming in 2003.

In 2007, students voted to replace Sam Maverick with a new Maverick incarnation, a blue-and-white horse, without horns. Students held another election in fall 2007 to name the horse. From a list comprised of Buck, Thunder, Blaze, Blazer, Blue, Erick, Rick, Poseidon, Maverick, and Spirit, Blaze came out on top.

Six

GRUBBWORMS, REBELS, AND MAVERICKS—OH MY!

The December 3, 1903, *Arlington Journal* cites a *Chicago Tribune* story claiming 19 people died on the football field that year. "One boy was driven insane from injuries," while numerous others were disabled for life, the *Journal* reports. Undaunted by this news, James Carlisle stated, "If a boy would become a complete man he must be more or less an athlete," and instituted an athletics program at Carlisle Military Academy.

The Carlisle Trolleys played Arlington's first-ever football game on October 1, 1904. The result was a loss to Oak Cliff 10-0. Despite the inauspicious beginning, football grew to have a strong following on campus and became the backdrop for many memories. Campus pride was never higher than when the Arlington State College football team won back-to-back Junior Rose Bowl titles in 1956 and 1957.

Confusingly described by the *New York Record* in 1894 as "a lawn tennis sort of a foot ball imitation," basketball has been a favorite sport at UT Arlington since the first game was played in 1908. Perhaps even more notable than the teams' win-loss records, though, was the basketball venue. From 1965 to 2012, the Rebels and the Mavericks played at Texas Hall—a multipurpose auditorium designed for plays and concerts as well as volleyball and basketball. *Sports Illustrated* listed Texas Hall as the nation's best place to watch basketball in 1997, baffling most people who had actually played there. More than one promising recruit said "no, thanks" after contemplating the danger of falling four feet off the court during game play. Still, the Stage, as it was known, saw some top-notch hoops action with both the men's (2008) and women's (2005, 2007) teams making it to the NCAA playoffs.

Over the years, other UTA sports have gained the national spotlight. Doug Russell brought attention to UTA's swim team after winning two gold medals in the 1968 Olympics. The major leagues regularly recruit Maverick baseball players. The wheelchair basketball team Movin' Mavs has won seven national titles. Surely Carlisle's intrepid Trolleys would be proud if they could see the results of their legacy.

Carlisle Military Academy fielded the school's first football team in 1904. This photograph shows the team around 1907, which was a particularly good year, with Carlisle amassing 136 points while limiting its competitors to a total of 16. The December 12, 1907, *Dallas Morning News* reports "the Carlisle football eleven has yet to meet its equal in this or any section of the State." Perhaps the training conditions at Carlisle helped the team succeed.

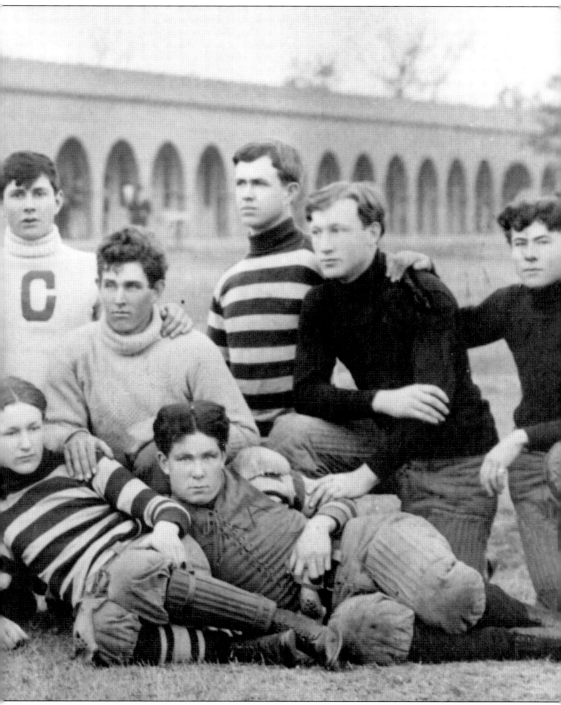

Interviewed by the *McKinney (TX) Courier-Gazette* in October 1975, 87-year-old William Aural Belden vividly recalled playing a game in Arlington against Carlisle when he was on the McKinney High School team in 1908. "The ground was about as hard as a concrete floor," he said.

Baseball was a national obsession when it started at Carlisle Military Academy in 1904. Teams would advertise in the newspapers, asking any teams interested in playing a game to contact them. Teams might be made up of players from a particular school, club, church, profession, or towns.

Track started at Carlisle Military Academy in 1907. Pictured here is the 1908 team, from left to right: (first row) John Neede, Ron Wakefield, Bill Norman, and Frank Lacy; (second row) Dennis McAfee, Leon Mistrot, Tom Lamonica, and J.D. Poland.

The Grubbs Hornets basketball team claimed the junior college state basketball championship in 1922 after archrival John Tarleton College forfeited the championship game, as neither side could agree on a location to play the final game. Because Grubbs had won eight of eight games and Tarleton won six of eight, Grubbs declared itself champs. Grubbs withdrew its claims on the championship three weeks later, leaving the title vacant.

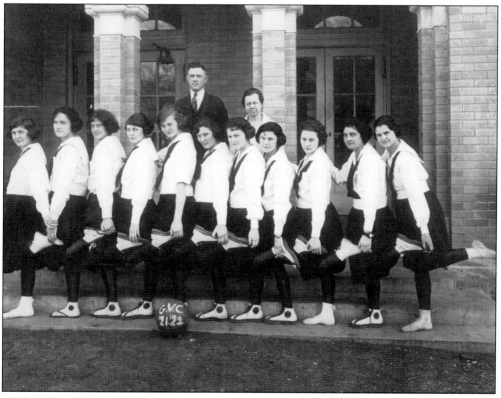

Modesty and femininity were important considerations for female athletes. Here, the Grubbs women's basketball team from 1921 to 1922 models a typical uniform of the period: a white middy blouse and wool bloomers. While girls' and women's basketball teams flourished in the 1920s, women were cautioned against overexerting themselves, becoming too competitive, and "going to pieces" after losing a game.

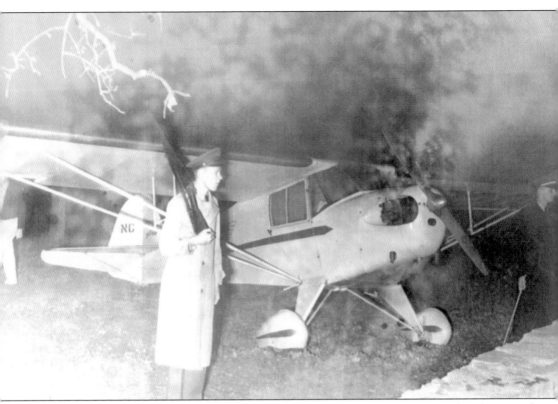

On a cool, cloudy November night in 1939, NTAC student Chester Phillips piloted a rented single-engine airplane southwest from Meacham Field. On board, freshman James Smith sat with a sack of phosphorus bombs ready to drop them on their target—the John Tarleton Agricultural College bonfire. Below on US Highway 377, NTAC forces were driving toward Stephenville with cans of gasoline and cigarette lighters in a coordinated ground assault. Little did they know the JTAC Plowboys were ready and waiting for them. The two rural junior colleges, each with an enrollment of about 1,000, had long engaged in a fierce sports rivalry. This latest incident started when JTAC students prematurely set fire to the NTAC bonfire ahead of the NTAC-JTAC football game. Incensed, ROTC Lt. Col. Nicky Naumovich plotted NTAC's counterassault. Though Naumovich's ground forces were repelled (with several NTAC students captured by JTAC students and having "T" shaved into their heads), Phillips and Smith reached the bonfire site and circled to make the first bombing run. One of Smith's bombs hit the target but was extinguished before it could ignite the pile. Other bombs fell in JTAC dean J. Thomas Davis's yard. (Courtesy of Tarleton State University, Dick Smith Library.)

Meanwhile, JTAC defenders climbed the nearby water tower and hurled rocks and debris at the low-flying plane, which was coming back around for a second run. JTAC fullback L.V. Risinger (pictured) hurled a wooden plank at the plane, lodging it in the propeller, and forcing Phillips to land in the ROTC drill field. Phillips and Smith, uninjured, were captured by a crowd of JTAC students. Afterward, there was talk of cancelling all games between the two schools, but the NTAC and JTAC deans decided to ban bonfires instead. NTAC went on to lose the football game to JTAC, 6-0. Smith was expelled for his role in the air raid, and an NTAC discipline committee recommended that Phillips have his pilot's license suspended. Risinger, who brought the plane down, was commended a few days later by JTAC's Dean Davis for his "attitude of cooperation and punctuality" and his perfect deportment record. (Courtesy of Tarleton State University, Dick Smith Library.)

Grubbs students play lawn tennis doubles outside Ransom Hall in the early 1920s. Tennis was introduced to the United States in 1874. It quickly gained popularity, especially in Texas where it could be played for most of the year. Tennis was first played as an Olympic sport in the 1924 Paris games.

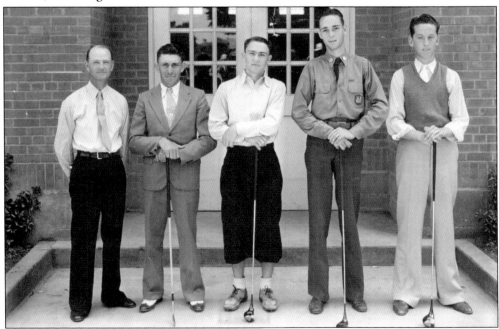

Col. Earl D. Irons, left, coached the NTAC golf team in the early 1930s. Irons, better known as composer, musician, and teacher, was also a strong lifelong golfer. He made headlines across the state in 1932 when he defeated the current state champion Gus Moreland at the River Crest Invitational. Legendary golfer Byron Nelson ultimately won the tournament.

In 1946, NTAC former students organization began work to erect a memorial to the 207 NTAC students killed in action during World War II. By the time the $60,000, all-steel War Memorial Stadium opened in September 1951, NTAC had a new name (Arlington State College) and a new mascot (the Rebels). Workers are shown here numbering the seats in the new stadium.

The NTAC Aggiettes drill team performed at all home and some away games. The *Vernon Daily Record* describes their uniforms in detail: "white majorette boots, royal blue pleated skirts, white battle jackets, decorated with citation cord, and blue and white overseas caps." Shown in this 1947 photograph are, from left to right, Wanda Norwood of Hobbs, New Mexico, and Annette Collier and Mary Ann Beckler, both of Dallas.

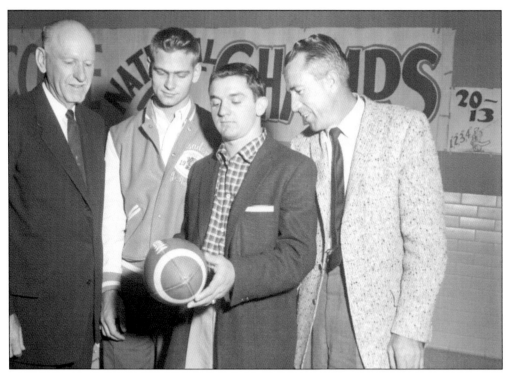

On December 8, 1956, the Rebels played in the Junior Rose Bowl in Pasadena and completed a stunning upset of Compton, California, 20-13. All 20 points were scored by 147-pound halfback Calvin Lee (holding ball). Lee was named MVP of the game. Others in the photograph are ASC president E.H. Hereford (left), quarterback Bobby Manning, and coach Chena Gilstrap. The *Dallas Morning News* reported that the most serious injury to Arlington came after the game when an ASC band member was hit on the head as the team and fans tore down the steel goalposts. The posts were tied to the top of the bus for the trip home to Arlington and erected on campus as a war prize. They are seen here in this 1965 photograph. The Rebels returned to the Junior Rose Bowl in 1957 and beat Cerritos, California, 21-12.

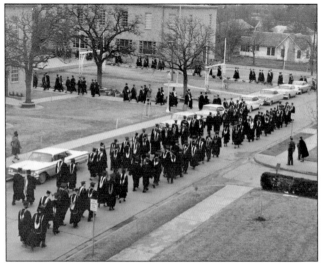

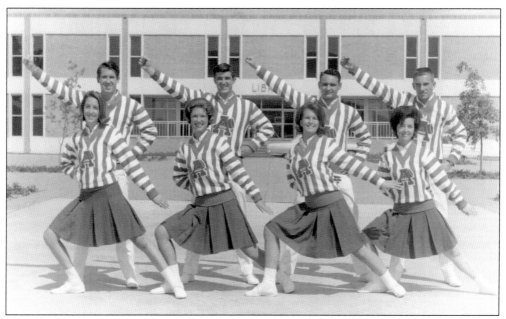

Rebel cheerleaders pose in front of ASC's new library in 1965. They are, from left to right, Lynn Petrelli, unidentified, Sharon Terrill, Buddy Lear, Becky Cowley, Mike Langdon, Sandy Barnes, and unidentified. Terrill, a 1964 graduate of Arlington High School, moved to California in her junior year and was crowned Miss California in 1968.

With the adoption of the Mavericks theme, UTA began a new series of spirit groups. Here the Maverick Marauders support the football team in the late 1970s. Note the man on the right giving the Mavericks hand sign. Early Maverick Marauders sponsored the homecoming float and appeared at pep rallies. Today, the Marauders are the governing body of the Student Alumni Association and organize the annual Oozeball event.

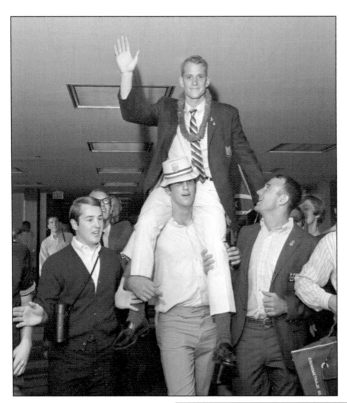

When UTA swimmer Doug Russell arrived at Love Field from the 1968 Mexico City Olympics, he was swept up by the jubilant crowd and carried right past Arlington mayor Tom Vandergriff. The Midland native won gold for the 100-meter butterfly and the 4 by 100-meter medley relay. He was a member of the ASC and UTA teams from 1966 to 1970, then coached at UTA until 1973. A park and street are named in his honor.

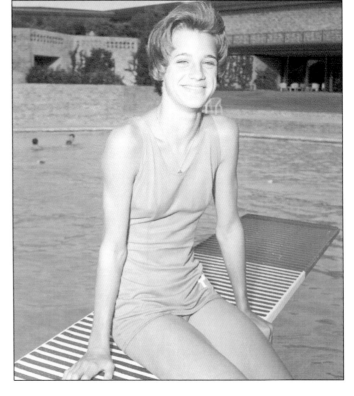

Burleson graduate Dashelle Maines competed on the 1965 ASC varsity swim team against male competitors. "When I told her my plans," ASC coach Don Easterling says in a 1965 *Dallas Morning News* article, "she said 'are you serious?" and I really was." Maines eventually lettered in the sport.

Texas Hall opened in 1965 as a multipurpose auditorium for athletic, theater, and concert events. Though *Sports Illustrated* listed Texas Hall as the nation's best place to watch basketball in 1997, most players and coaches disliked the venue. Texas Hall continued to be used for basketball and volleyball games until College Park opened in 2012.

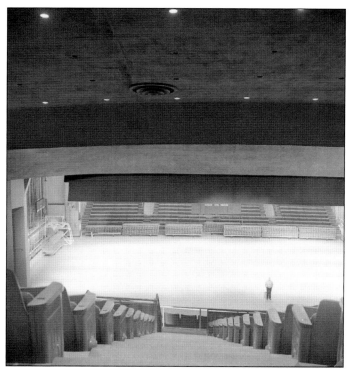

Fast-growing Arlington State College outgrew Memorial Stadium in only 20 years. The stadium was demolished in 1972, forcing the football team to face the ignominy of playing on high school fields. A long eight years later, Maverick Stadium opened in September 1980. Here, workers are laying artificial turf before the first game against North Texas State University.

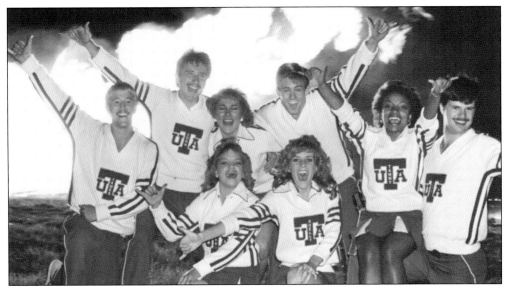

In the years after the Tarleton bonfire incident, bonfires came and went on campus with rival schools still trying to prematurely light each other's fires. The last homecoming bonfire tradition ignited in 1977, after a decade-long hiatus. Here, cheerleaders pose in front of the 1984 bonfire during the penultimate football season.

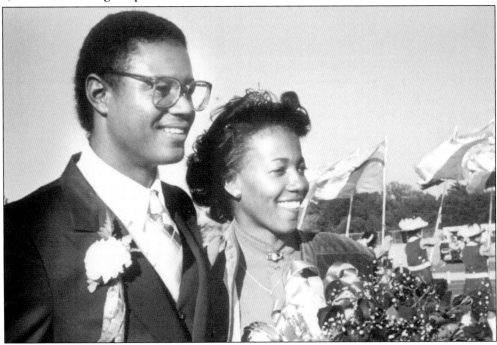

Wanda Holiday became the campus's first African American homecoming queen in 1980. Her election was seen as a significant step in promoting minority participation in campus life, but Holiday made it clear that she planned to represent the entire campus. "I don't want to be just a representative for the minority students," Holiday told the campus newspaper. "I just want to represent the entire student body." Rodney Lewis was named UTA's first-ever homecoming king.

Despite winning the Pecan Bowl in 1967 and finishing first in the 1981 Southland Conference, the school's football program never reclaimed the glory years of 1956 and 1957. The team struggled to find success and an audience. Even a new football stadium in 1980 failed to boost attendance at games. UTA's final coach, Chuck Curtis (wearing hat), watches the opening game of the 1984 season.

In a move that stunned the community, UTA president Wendell Nedderman, right, announced the elimination of the UTA football program on November 25, 1985. The cost of a program that drew few fans and even fewer students had become too much to overcome. "Somebody would have to come up with a million dollars a year for an indefinite period" to save the program, he said.

UTA sophomore tackle Ed Newman sits in the locker room after learning that the football program was gone. The sudden end was made more painful by the belief among many that the team was positioned to significantly improve the following season. "We've made such great progress," Dean Teykl, a sophomore tight end, says in a 1985 *Dallas Morning News* article by Sam Blair. "It's a shame a handful of people could flush so many people's dreams down the drain." The players, now without a team, could transfer to another school without loss of eligibility or continue at UTA on scholarship. In a 1998 *Dallas Morning News* article, coach Curtis recalls placing about 40 players in other programs. "I remember when coaches from other schools came in to visit the players. It was like kids in a candy store." One player on that final team, Tim McKyer, was drafted by the San Francisco 49ers and helped the team win Super Bowls XXIII and XXIV, then helped the Denver Broncos win Super Bowl XXXII.

The day after the announcement, about 200 students gathered at Maverick Stadium to show their support for keeping football. Despite the obvious emotion on display, the small rally and a sparsely attended community rally a week later failed to save football. UTA political science associate professor Allan Saxe is quoted in *Transitions* by Gerald Saxon as saying "70 percent [of the student body] would say they are not heartbroken over dropping football. 10 percent are heartbroken, and the remaining 20 percent did not know UTA even had a team." His estimate was reinforced by students like Richard Hair, interviewed about the end of football by the *Dallas Morning News* in 1985. "This is a commuter school," he said. "A lot of students here work and live off campus. Their lives don't revolve around the school."

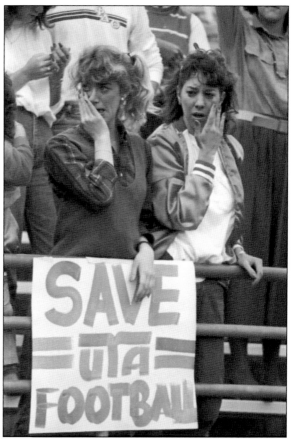

With football gone, volleyball soon became a campus star. In 1989, the volleyball team beat 1988 national champions University of Texas to be the first UTA team in any sport to reach an NCAA Final Four. "As we walked into the gym, we were met by all the Texas fans who were wearing leis in anticipation of the final four in Hawaii," Pete Carlon told the *Dallas Morning News*. "They all thought they were going to Hawaii, and we beat them." UTA lost to eventual champion Long Beach State. Still, then-coach Cathy George calls it "a fairy tale" in a 1999 *Arlington Morning News* interview. "Arlington really was the Cinderella story then." The team is shown in action against Texas and after the game.

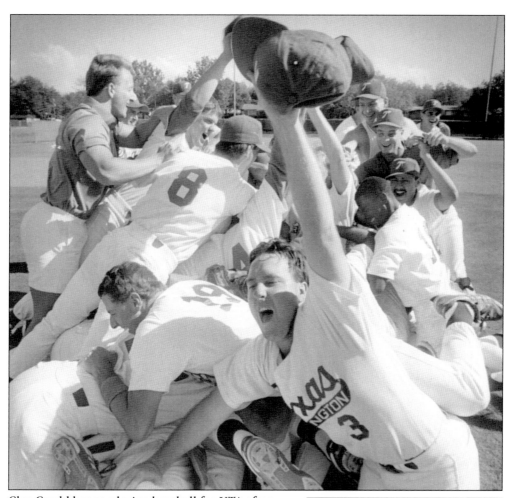

Clay Gould began playing baseball for UTA after graduating from Arlington High School in 1989. In 1990, he helped the team win its first conference championship. The team is shown celebrating after beating Sam Houston State to win the Southland Conference title. Gould had an outstanding college career, including being honored as 1993's Southland Conference Player of the Year. When UTA's head baseball coach Butch McBroom stepped down in 1999, Gould, 27, the hometown hero and UTA assistant coach, was named his replacement. Gould's absolute commitment to and enthusiasm for UTA baseball helped lead the team to the NCAA tournament in 2001. Gould was first diagnosed with colon cancer in 2000, but carrying a chemotherapy pack, he continued to coach throughout the 2000 season. In April 2001, he learned the cancer had spread. He died two months later. UTA's Allan Saxe baseball field was renamed Clay Gould Ballpark in 2003.

In 1976, concerned that so many disabled people died early deaths because of a sedentary lifestyle, UTA alumnus and coach Jim Hayes, shown here playing in 1985, started the Freewheelers wheelchair basketball team. In 1988, the team joined the National Wheelchair Basketball Association and changed its name to the Movin' Mavs. The Movin' Mavs have won seven national titles and sent 20 athletes to the Paralympics.

Mechanical engineering professor Robert Woods has been leading UTA's Formula Society of Automotive Engineers (FSAE) team since its beginning in 1982. Each year, the team, made up of students from a variety of disciplines, designs and builds a race car for competition. Shown here is the first-place car from the 1986 season with three unidentified students. The UTA team has won national and international competitions and was ranked fifth in the world in 2014.

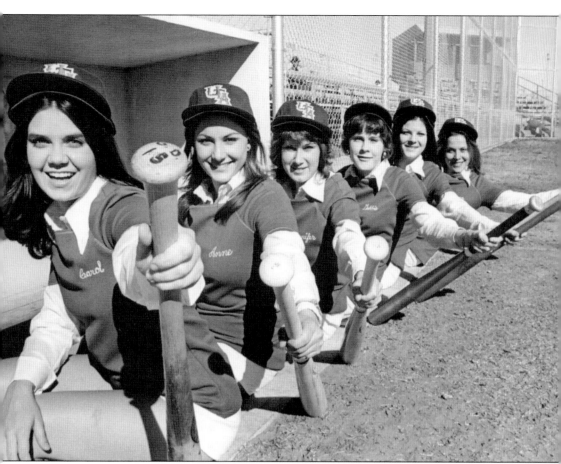

Grubbs Vocational College fielded a women's basketball team, but women's athletics were largely ignored. Prevailing myth held that if women participated in sports, their femininity would be compromised. This attitude was evident in a 1971 decision by the Connecticut Supreme Court that denied a young woman the right to participate in a high school cross-country team. The decision notes, "Athletic competition builds character in our boys. We do not need that kind of character in our girls, the women of tomorrow." Everything began to change with Title IX of the 1972 Education Amendments Act, which mandates equal treatment of girls and women in all levels of education. As a result, four women's sports—volleyball, basketball, softball, and track—moved into UTA's athletic department in 1973. Today, women's cross-country and tennis have been added to the list.

UTA's women's basketball team won the Southland Conference Tournament in 2005 against Louisiana-Monroe 60-54 and earned its first trip to the NCAA tournament. "We wanted to dance," coach Donna Capps told the *Dallas Morning News*, referring to the NCAA tournament. "We got dancers on our team." Two of those dancers were Rola Ogunoye and Tarra Wallace, SLC tournament MVP. At the NCAA tournament, the No. 13 seed Mavs faced fourth-seeded Texas Tech at Reunion Arena on March 19, 2005. Tech went on to advance after beating the Mavericks 69-49. Ogunoye left UTA to play basketball for a Swiss team the following year, but Wallace returned to play for UTA. The team is shown here in 2005.

Seven

TRADITIONS, PAST AND PRESENT

Students forget many of the professors they had and even the classes they took, but they do not forget the traditions that made their college experience special. Traditions bind a campus together through generations of students. Some traditions may fall away and others take their place, but they are always considered special and unique.

Through the different eras of UT Arlington, traditions have been established by students, faculty, and administration. Of course, one of the most celebrated traditions at any university is commencement. At Carlisle, the closing exercises lasted a week and included oral and written examinations, sermons, entertainments, and awards. Grubbs graduation ceremonies were small. In five years, the school graduated 61 students.

At NTAC, Dean E.E. Davis invited graduates to a garden party held at his home. The big news for ASC was when it could award its first bachelor's degrees in 1961. UTA awarded its first master's degrees in 1967 and its first doctorates in 1971.

On the opposite end of the college experience, welcoming students to campus also has traditions surrounding it. UTA hosts a week of activities starting with Move-in Day and including MavsMeet Convocation and Maverick Stampede.

Throughout the year, students can see and participate in Greek step shows, International Week, Bed Races, Oozeball, and Homecoming.

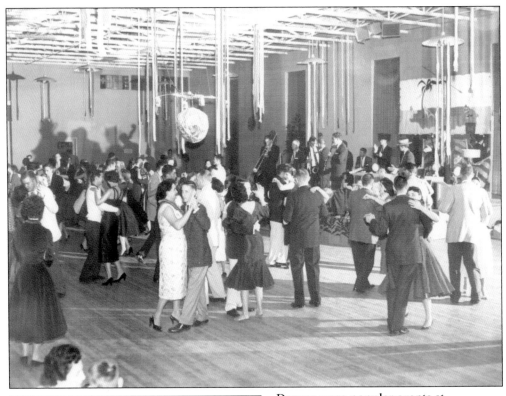

Dances were popular events at ASC. There were welcome dances, homecoming dances, sorority dances, military balls, holiday dances, after-game dances, and even Thursday dances. Formal dances, like the one in this undated photograph, featured traditional moves like the waltz and foxtrot. But ASC students got plenty of opportunities to show off the latest dance fads like the twist, mashed potato, and the frug.

ASC's Western Day featured barrel roping, sack races, egg tossing, and tug-of-war. Women could compete in the cigar-smoking contest while men, such as Robert Thomas (shown here in 1965), could compete in the tobacco-spitting contest. The day ended with an all-college rodeo in Kow Bell Arena in Mansfield.

As part of the Texas A&M System, Arlington was not allowed to have a national Greek system on campus. That changed when the school joined the University of Texas System. Here, fraternity men pose on Cooper Street in front of Central Library in the mid-1980s.

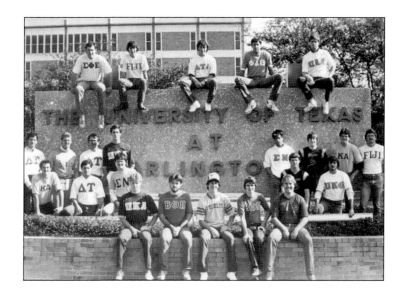

The Winter Olympics are an annual tradition sponsored by the fraternities and sororities. Here, Les Choisies members Cheryl Spain and Martha Jo Fry compete in a chariot race in 1965. The Winter Olympics feature silly events like musical tubs (the tubs being filled with flour, water, and raw eggs) and pogo jumping.

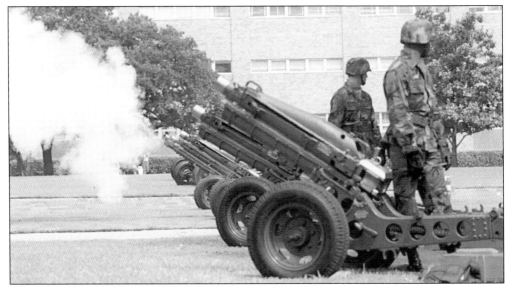

UTA's military heritage is reflected in the Carlisle Cannons. In 1983, the Corps of Cadets bought six Korean War–era howitzer cannons. Eventually, five were sold off, but two have been reacquired for a total of three. The cannons are fired for special occasions. NTAC had a cannon called Little Bertha and ASC used a Civil War–era replica called Roaring Rebel. (Courtesy of the University of Texas at Arlington.)

Living away from home for the first time can be exhilarating, scary, and tiring. Fortunately, there are plenty of people to help new and returning students get settled in their new home during Move-in Day, as this 2010 photograph shows. In 2013, about 4,300 students lived in on-campus housing, marking a big switch from the days UTA was known as a commuter school. (Courtesy of the University of Texas at Arlington.)

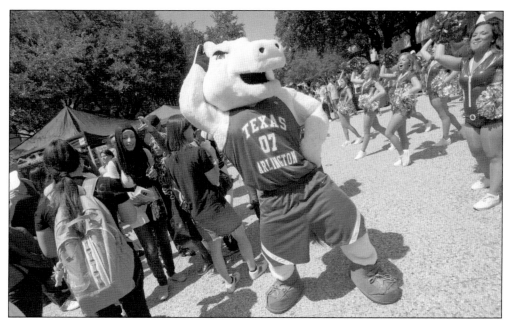

Thousands of students wander the booths of businesses, college departments, and student organizations during the Activity Fair, held on campus since 1981. Students can learn about volunteer and leadership opportunities, play games, see a step show, climb a rock wall, and pick up lots of free goodies. Above, UTA mascot Blaze strikes a pose in 2010. The Maverick Cookout is held in conjunction with the Activities Fair as a part of the Maverick Stampede. Faculty and staff volunteers hand out drinks and grill burgers, which, in recent years, have included a vegetarian option. Pictured at right, UTA president James Spaniolo flips patties in August 2009. (Both, courtesy of the University of Texas at Arlington.)

Maverick Stampede is a campus-wide event that introduces students to the campus and to each other. Called Welcome Days before 2006 and informally called Welcome Week, the Stampede includes the Convocation and AfterParty, Waffleopolis, and the Maverick Cookout. Students in this 2013 Stampede photograph compete in a pie-eating contest hosted by the library. (Courtesy of the University of Texas at Arlington Libraries.)

The MavsMeet Convocation started in 2004 as a way to welcome new and returning students to campus. The formal event features the UT Arlington Marching Band as well as faculty, staff, and student speakers. After the ceremony, students celebrate at the AfterParty with games, music, and food. UTA president James Spaniolo is pictured second from right. (Courtesy of the University of Texas at Arlington.)

Students get down and dirty during the 1997 Oozeball tournament. The mud volleyball competition, which started in 1989, pits students, faculty, staff, and alumni against each other on a court filled with ankle-deep mud. Players have been known to duct-tape their shoes on their feet to prevent them from slipping off. The proceeds from the tournament support student scholarships. (Courtesy of the University of Texas at Arlington.)

After football ended in 1985, homecoming moved to the spring semester to celebrate basketball season. Here, students show off canned goods collected for a food drive during Homecoming 1997. Homecoming moved back to fall in 2012. Today, the celebration still includes the crowning of a homecoming king and queen. Other popular events are the Maverick Step Show and the golf cart parade.

UTA's International Week is a celebration of culture that reflects the diversity of campus. Started in 1977, the event showcases the fashion, dance, and customs of thousands of international students at UTA. This dancer appears to float above the ground as she performs outside the Hereford University Center in 1987.

One of the most anticipated events during International Week is the Food Fair. Visitors can sample dishes from places like the Ivory Coast, Korea, India, and Brazil all within the space of the University Center Mall. "We want everyone to know what our culture looks like, to be exact, tastes like," Pakistani student Tazeen Jafri told the *Shorthorn*.

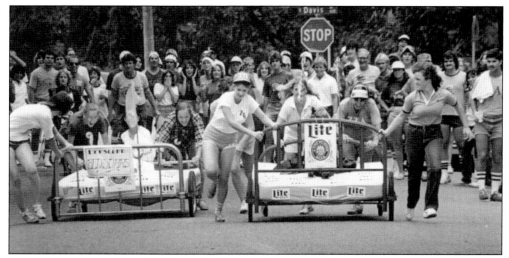

Billed as the longest-running tradition at UTA, bed racing came to campus in 1980. The idea is simple: Put a bed on wheels, find someone to lie on the mattress and hang on tight, then get a team to push the bed to the finish line. As shown in this 1981 image, UT Arlington's Bed Races were originally held on Greek Row. Today, they are run in Maverick Stadium.

The annual spring Big Event is a day of service to the Arlington community by hundreds of UTA students. Projects can include cleaning parks, planting gardens, working with children, assisting Mission Arlington, or helping at the Arlington animal shelter. This photograph is from the 2013 Big Event.

Engineers Week is celebrated the same week as George Washington's birthday as he is considered America's first engineer. Engineers Week showcases the important contributions engineers make to everyday life. Originally called Engineering II when it opened in 1988, this building was renamed Nedderman Hall in 1991 after UTA president Wendell Nedderman, who came to UTA in 1959 as the first dean for the College of Engineering.

The College of Engineering began hanging international flags in Nedderman Hall in 1989. Each flag represented a student in the engineering program from that country. In 2006, the flags were removed and replaced with identical blue banners after protests over the display of the flag of the Socialist Republic of Vietnam.

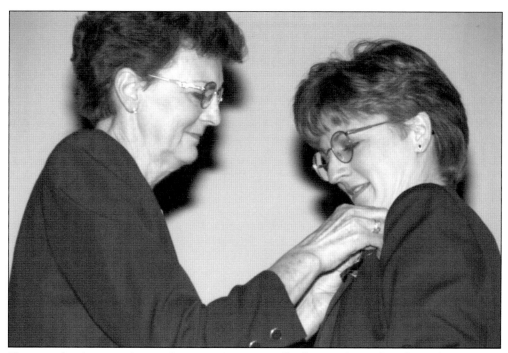

Upon graduation, nursing students receive a specially designed pin identifying them as UTA graduates. "Everyone tries to ask a significant other or family member to do [the pinning]," Genelle Tulley told the *Dallas Morning News*. "It is kind of a way to also thank our families for being so supportive while we studied and worked." The women in this 1996 ceremony are not identified.

There's no egg on anyone's face in this semiannual competition. From the fourth floor of the Fine Arts Building, students in the three-dimensional design class drop contraptions designed to prevent a raw egg from breaking. Some work well, others land in a broken heap, but it is all fun for the dozens of spectators who come to watch.

The annual UTA glass sale supports the glass program, the only such program in the state. Students, faculty, and visiting artists create pieces for the sale and half the sales price is returned to the artist. Prices range from a few dollars to thousands, and people line up early on sale day to claim the best pieces.

A little good luck goes a long way. For decades, the bronze bust of former ASC president Hereford as served as a good luck symbol. If a student rubs his head before a test, he or she is said to guaranteed to pass. Today, there is even a virtual way to rub Hereford's head. Just go to www.uta.edu/universitycollege/resources/hereford.php. (Courtesy of the University of Texas at Arlington.)

Eight

ACADEMICS

While clubs, sports, and traditions make the college experience memorable, education is, after all, about classrooms, students, and teachers. At first, the focus was upon liberal arts education, with students being prepared for college. During some of those years, military training helped foster discipline and healthy bodies. With the advent of Grubbs Vocational School in 1917 and the belief that education should focus upon preparing the average citizen to support the ever-growing industrial and agricultural needs of the nation, courses that focused upon vocational education became part of the school's catalog. As part of the Agricultural and Mechanical College of Texas (Texas A&M) System, the school continued the tradition of military training. Again, as times changed and students and the community required different skills, North Texas Agricultural College and later Arlington State College added courses to support both the war effort and the needs of an industrial society. When Arlington State College gained senior college status, the school's departments included agriculture, arts and sciences, business administration, engineering, and fine arts. ASC and later University of Texas at Arlington elevated some departments to colleges, developed new colleges, and discontinued others. Engineering flourished while the Department of Agriculture with courses in agronomy, poultry husbandry, and farm management was removed.

The School of Nursing, later the College of Nursing, became part of UT Arlington when the University of Texas System moved the University of Texas School of Nursing at Fort Worth to the University of Arlington in 1976.

The current colleges and departments at UTA reflect the changes made by the university because of growth, war, integration, social movements, and advances in technology. With 10 schools and colleges and numerous centers, the University of Texas at Arlington continues to adapt to its student's needs.

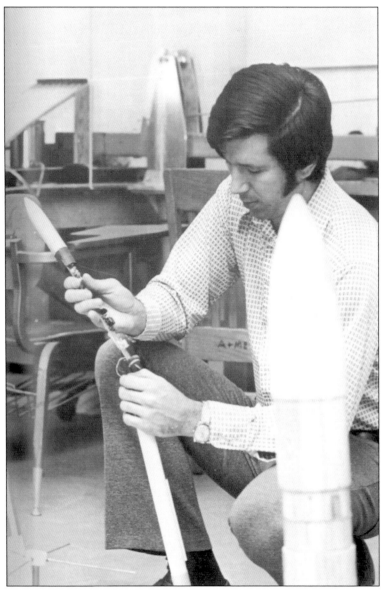

Engineering has long been a strength for UT Arlington. When ASC was made into a four-year institution in 1959, engineering was one of the first programs to offer a bachelor's degree. The first baccalaureate degrees in electrical and mechanical engineering were awarded in 1961 to 23 students. When graduate programs were approved in 1966, engineering again led the way with the first master's degrees awarded in 1968. Three of UTA's past presidents have come from an engineering background: Jack Woolf (1958–1968), Wendell Nedderman (1972–1992), and Vistasp Karbhari (2013–). Today, UTA's College of Engineering graduates hundreds of students from around the world in bioengineering, civil engineering, computer science, electrical engineering, industrial engineering, materials science, and mechanical and aerospace engineering. Campus facilities include the Aerodynamics Research Center, Civil Engineering Lab, Engineering Research Building, Nedderman Hall, Woolf Hall, and Optical Medical Imaging Laboratory. Here, an unidentified aerospace engineering student assembles a rocket in 1975.

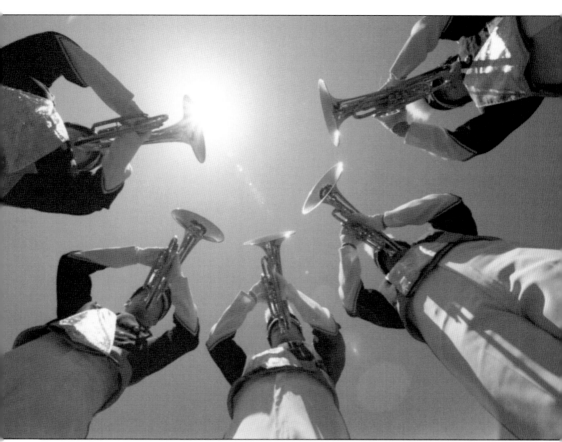

University of Texas at Arlington was founded as a private liberal arts institution. The current College of Liberal Arts was established in 1965 when Arlington State College separated from the Texas A&M System and joined the University of Texas System. Liberal Arts offers 17 different majors and additional minors covering fields in humanities, social studies, and fine arts. In addition, it offers 12 programs leading to master of arts degrees and three doctorates and has been actively engaged in distance education. The college offers a number of classes online that engage and support students off campus. Doctoral programs in English, transatlantic history, and linguistics have been recognized by the Texas Higher Education Coordinating Board. The Department of Music has a full schedule of events that offer performance opportunities and entertainment for the community.

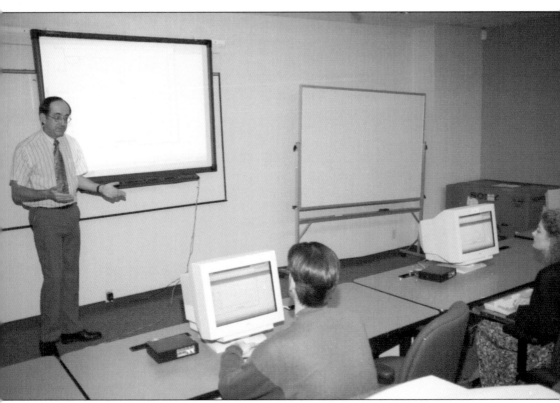

The College of Business was established in 1965, after the Texas Commission on Higher Education approved its separation from the ASC School of Arts and Sciences. With over 1,000 graduates annually, the program is today the second-largest on campus, after nursing. Students can earn degrees in accounting, economics, finance, real estate, information systems and operations management, management, and marketing. Graduate programs began in 1968. The College of Business also offers an executive MBA program with classes in downtown Fort Worth and an EMBA in China known as the UTA Asian EMBA. Two past presidents of UTA have had a business background: Ryan Amacher (1992–1995) and Robert Witt (1995–2003). Shown here is Mark Eakin teaching a business class in 2000. The College of Business Administration building (COBA) was dedicated in 1978.

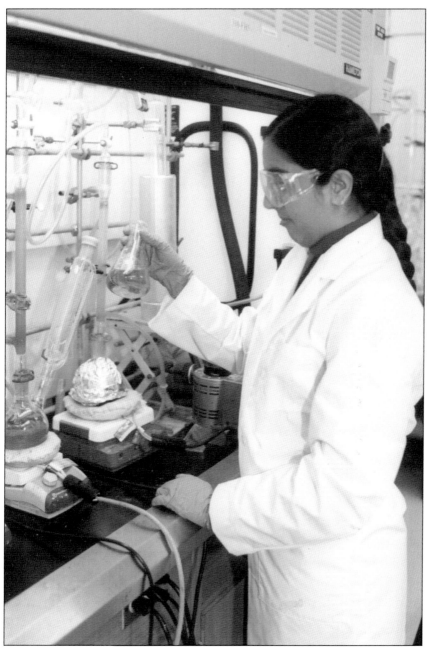

The College of Science was established in 1965 after the Texas Commission on Higher Education approved its separation from the ASC School of Arts and Sciences. Today, nearly 4,000 students study biology, chemistry, biochemistry, earth and environmental sciences, mathematics, physics, and psychology in the college. The first science building was erected in 1928 and rededicated as Preston Hall in 1950 to honor Joe B. Preston, a former history professor and registrar. What is today known as Science Hall was built in 1950. Other notable buildings include the Chemistry and Physics Building that opened in 2006. Besides state-of-the-art labs and research facilities, the building houses the planetarium, which hosts thousands of local elementary and secondary students each year.

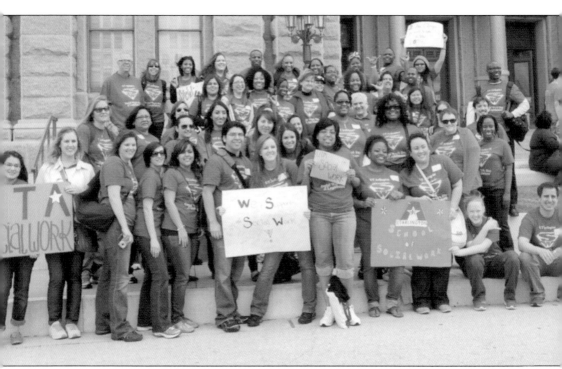

Studies in the 1960s showed a great need for qualified social workers, but no local educational facilities were available to help prepare them. The UTA School of Social Work began offering a two-year master's degree in social work in 1968—the first of its kind in the region. The first year, 26 students entered the program. A bachelor's program was established in 1979 and a doctoral program in 1983. Today, over 1,326 students are enrolled in the School of Social Work. In 1968, the university bought Ousley Junior High on the north end of campus to hold the School of Social Work, Institute of Urban Studies, and printing and television facilities. Ousley had previously been the original Arlington High School built in 1922. (Courtesy of the University of Texas at Arlington School of Social Work.)

The College of Education began as the Center for Professional Teacher Education in 1997. It became the School of Education in 1999 and the College of Education in 2003. Today, the College of Education has about 2,600 students studying curriculum and instruction, as well as educational leadership and policy. Seated in this photograph is Mary Lynn Crow, clinical psychologist and professor of education. Crow started at UT Arlington in 1969 after six years as Miss Mary Lynn on the television show *Romper Room*. She quickly established herself as one of UTA's most celebrated professors. She and Allan Saxe (left) are shown here with UTA president Frank Harrison in 1972 as the first recipients of UTA's Outstanding Teaching Award. In 2009, Crow was named one of the first recipients of the University of Texas System Regents' Outstanding Teaching Award.

Former UT Arlington dean of nursing Myrna Pickard traced the roots of the College of Nursing to the 1890 John Sealy hospital Training School of Nurses in Galveston. It was organized as an independent school under a board of female managers and transferred to the University of Texas in 1986. In the fall of 1972, sixty-seven students were admitted to the University of Texas School of Nursing in Fort Worth. Nursing education once again relocated when the University of Texas System made each of the system schools part of the nearest University of Texas institution in 1977. Now known as the UT Arlington College of Nursing and Health Innovation, the college is in Pickard Hall (above), named in honor of founding dean Myrna Pickard. The college offers programs ranging from the bachelor's degree through doctoral studies in traditional classrooms (below). In addition, the college's Smart Hospital with more than 40 patient simulators offers virtual resources for educating future nurses.

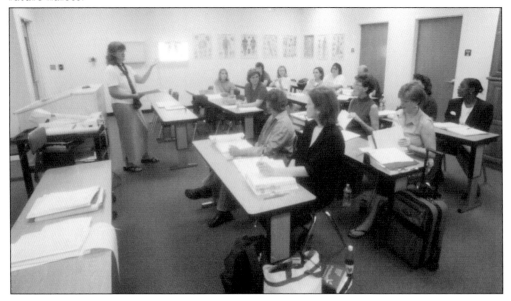

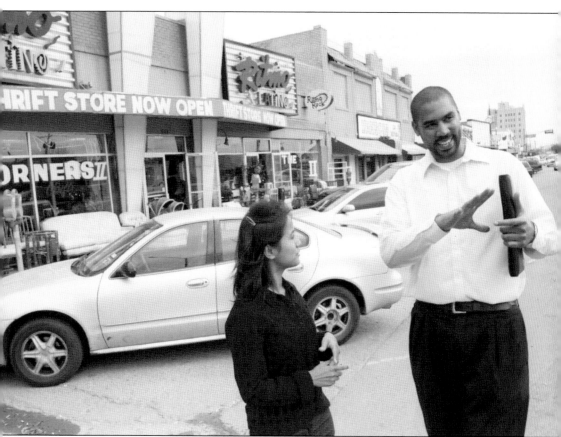

In 1967, the School of Urban and Public Affairs was established as the Institute of Urban Studies by an act of the Texas Legislature. The program had been championed by Arlington mayor Tom Vandergriff, who considered it one of his most important legacies. The institute's first director, Edward Overman, told the *Grand Prairie Daily News* that the long-term objective was "to work towards a synthesis and unification of knowledge and methodologies of several disciplines for more effective urban problem solving and a clearer understanding of the urbanization process." In 1990, the organization that grew up around the institute became the School of Urban and Public Affairs. The institute still operates within the school and offers economic development plans, site selection services, feasibility studies, transportation plans, and more to communities around the state. (Courtesy of the University of Texas at Arlington.)

UTA's Department of Architecture in the College of Liberal Arts became the School of Architecture in 1975. Students can earn bachelor's degrees in architecture and interior design, and master's degrees in architecture and landscape architecture. The landscape architecture program was ranked 13th in the nation by *DesignIntelligence* in 2013.

UTA's Honor program was designated as the Honors College in 1999, the first one in North Texas and the third in the state. "Honors students do not take more courses than non-Honors students; instead, they opt to fulfill more rigorous requirements than non-Honors students in several courses, and work closely with faculty mentors, with a focus on research," wrote Karl Petruso, Honors College dean. The Honors College is compatible with any major.